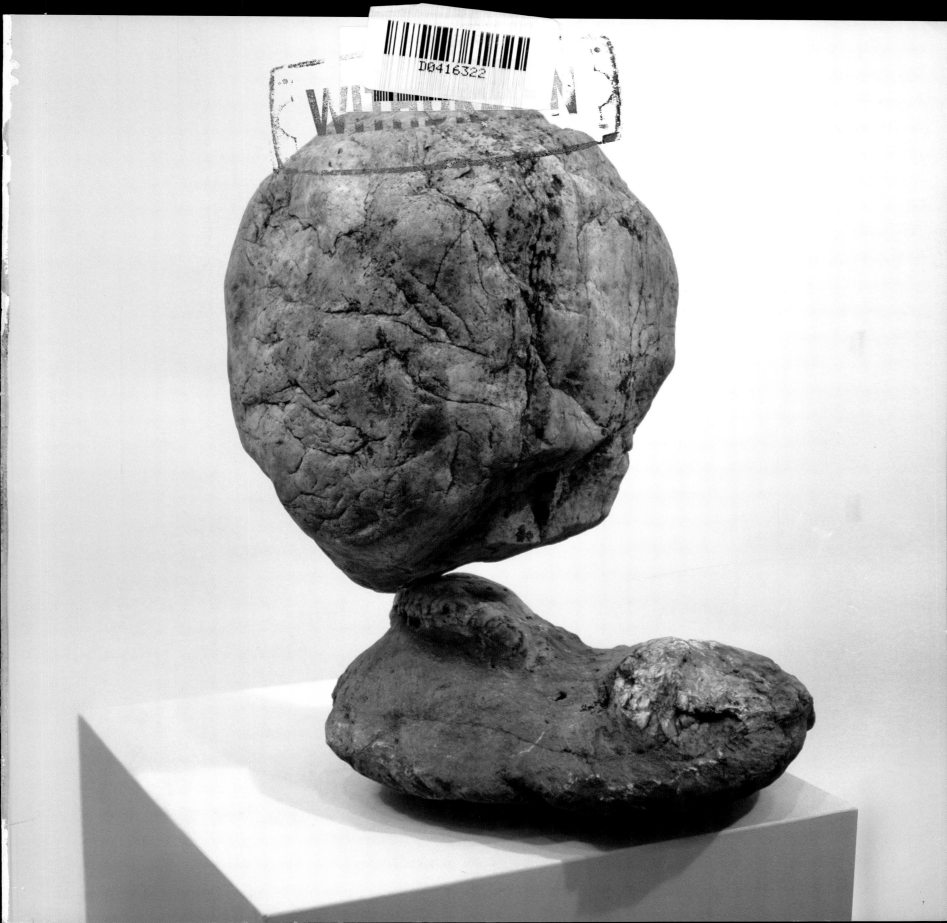

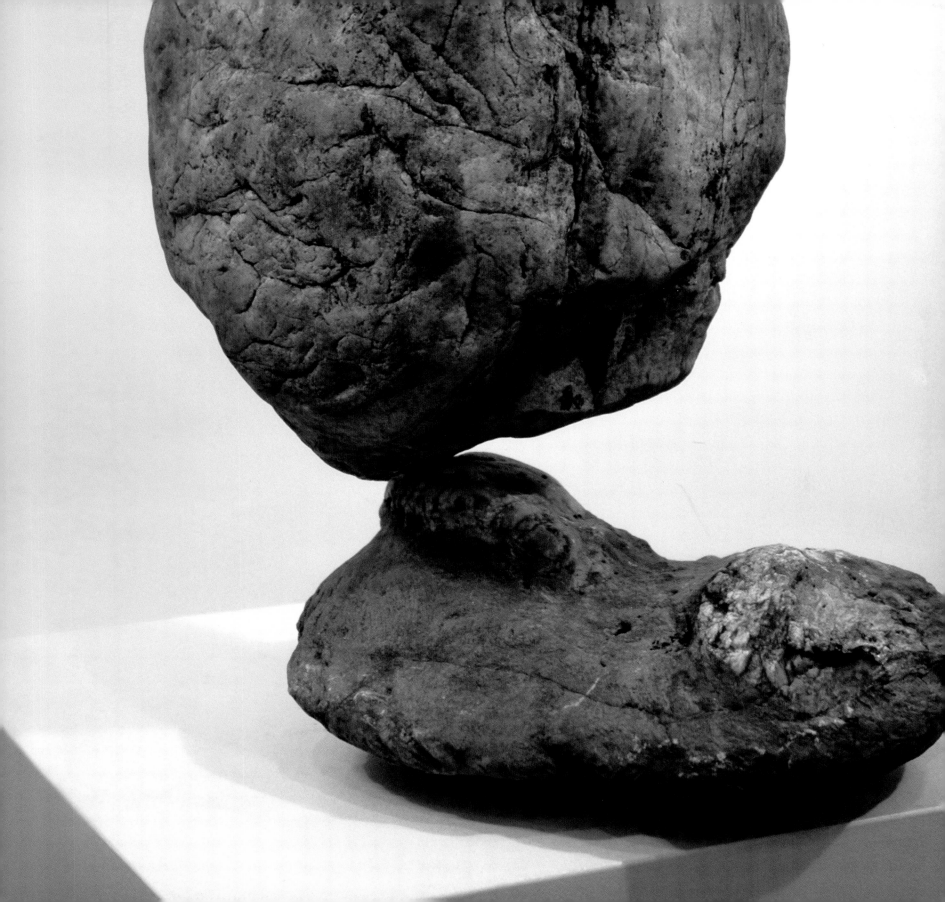

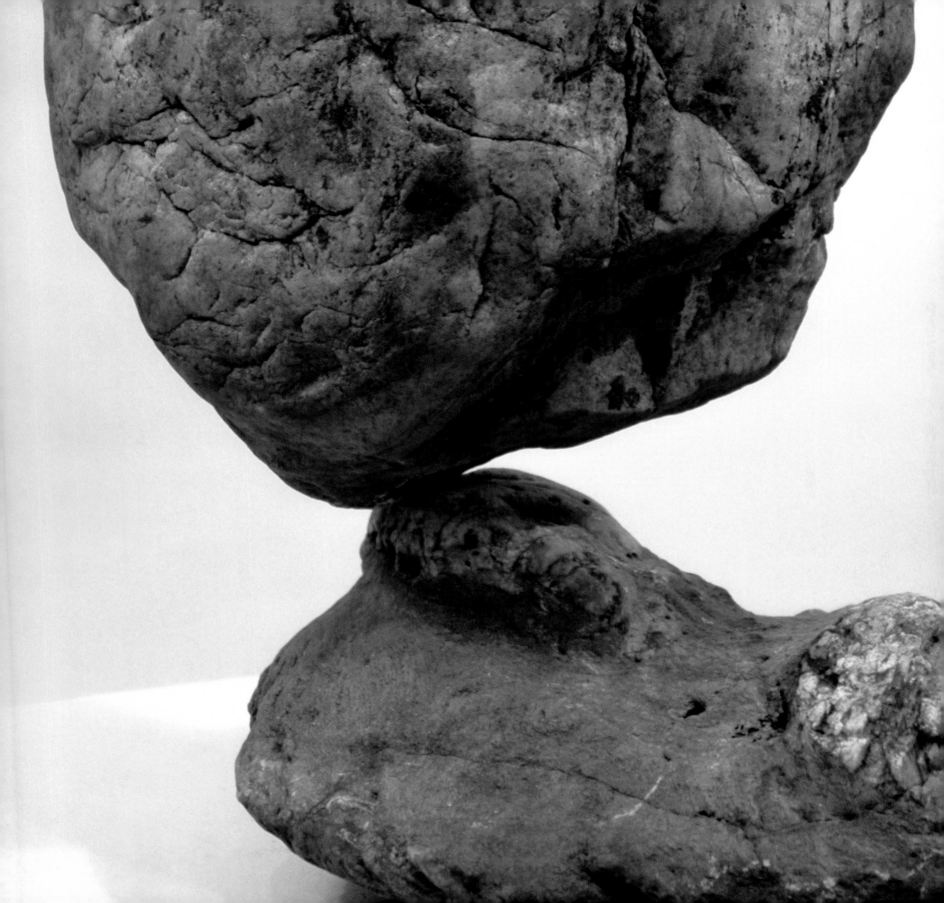

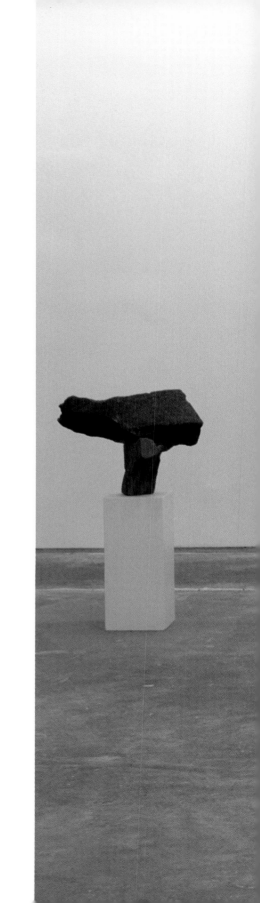

photo at Baumgartner Gallery, 2004

photography by Sherry Williams

Axial Stones

an art of precarious balance

George Quasha

foreword by CARTER RATCLIFF

map of stones

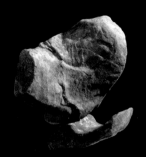

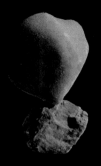

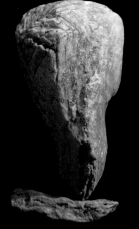

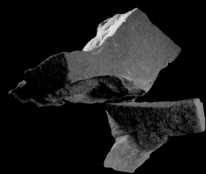

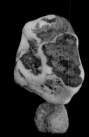

Axial Stones 1
PAGE 36

[13.5" x 12" x 7.5"]
[34 x 30 x 19 cm]

Axial Stones 2
PAGE 100

[11" x 8.5" x 5.5"]
[28 x 22 x 14 cm]

Axial Stones 3
PAGE 46

[24" x 11.5" x 8"]
[61 x 29 x 20 cm]

Axial Stones 4
PAGE 62

[17" x 20" x 18"]
[43 x 51 x 46 cm]

Axial Stones 5
PAGE 114

[6" x 11" x 6"]
[15 x 28 x 15 cm]

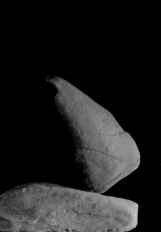

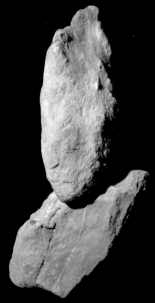

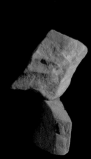

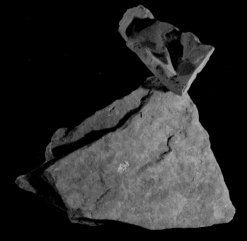

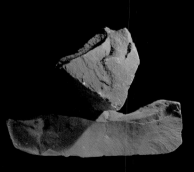

Axial Stones 6
PAGE 66

[16" x 16.5" x 8.5"]
[41 x 42 x 22 cm]

Axial Stones 7
PAGE 142

[27.5" x 11.5" x 10"]
[70 x 29 x 25 cm]

Axial Stones 8
PAGE 96

[11" x 7" x 6"]
[28 x 18 x 15 cm]

Axial Stones 9
PAGE 134

[20" x 17.5" x 12"]
[51 x 44 x 30 cm]

Axial Stones 10
PAGE 54

[18.5" x 14" x 7"]
[47 x 36 x 18 cm]

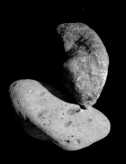

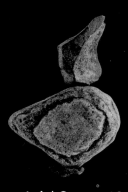

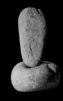

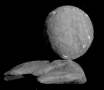

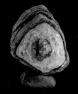

Axial Stones 11
PAGE 140

[10" x 10" x 7"]
[25 x 25 x 18 cm]

Axial Stones 12
PAGE 70

[14" x 9" x 2.5"]
[36 x 23 x 6 cm]

Axial Stones 13
PAGE 118

[7" x 4" x 6"]
[18 x 10 x 15 cm]

Axial Stones 14
PAGE 52

[7" x 6" x 7.5"]
[18 x 15 x 19 cm]

Axial Stones 15
PAGE 144

[6" x 4" x 3.5"]
[15 x 10 x 9 cm]

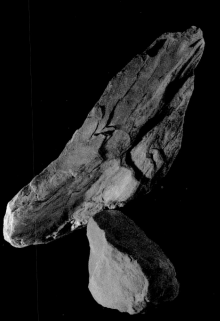

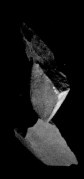

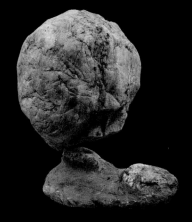

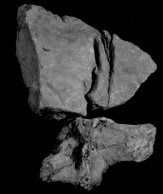

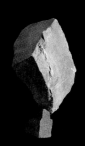

Axial Stones 16
PAGE 130

[29.5" x 20" x 12"]
[75 x 51 x 30 cm]

Axial Stones 17
PAGE 68

[16.5" x 6"x 1"]
[42 x 15 x 3 cm]

Axial Stones 18
COVER

[16.5" x 15.5" x 11"]
[42 x 39 x 28 cm]

Axial Stones 19
PAGE 72

[16.5" x 13.5" x 6.5"]
[42 x 34 x 17 cm]

Axial Stones 20
PAGE 132

[20" x 20" x 16"]
[51 x 51 x 41 cm]

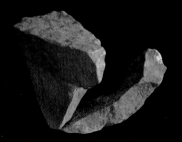

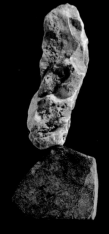
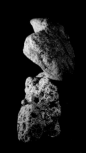
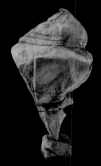

Axial Stones 21
PAGE 104

[11.5″ x 11″ x 10.5″]
[29 x 28 x 27 cm]

Axial Stones 22
PAGE 112

[9″ x 5.5″ x 5″]
[23 x 14 x 13 cm]

Axial Stones 23
PAGE 86

[18″ x 8″ x 9″]
[46 x 46 x 23 cm]

Axial Stones 24
PAGE 120

[12.5″ x 11″ x 5″]
[32 x 28 x 13 cm]

Axial Stones 25
PAGE 146

[15″ x 8.5″ x 5″]
[38 x 22 x 13 cm]

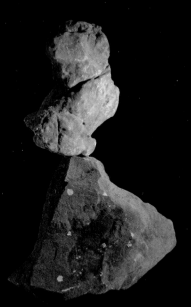
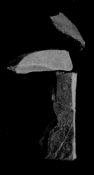
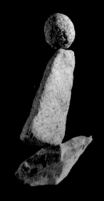
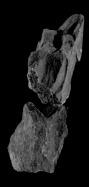
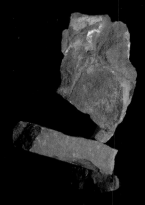

Axial Stones 26
PAGE 136

[36″ x 22.5″ x 14″]
[91 x 57 x 36 cm]

Axial Stones 27
PAGE 108

[18″ x 6″ x 7.5″]
[46 x 15 x 19 cm]

Axial Stones 28
PAGE 84

[13″ x 9″ x 4.5″]
[33 x 23 x 11 cm]

Axial Stones 29
PAGE 116

[16″ x 6.5″ x 4.5″]
[41 x 17 x 11 cm]

Axial Stones 30
PAGE 42

[21″ x 13″ x 8.5″]
[53 x 33 x 22 cm]

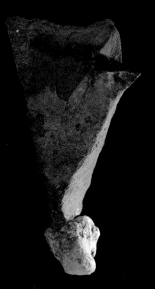

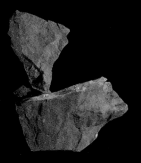

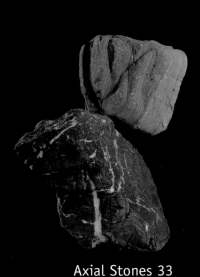

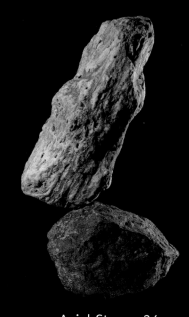

Axial Stones 31
PAGE 92

[27" x 14" x 13"]
[69 x 36 x 33 cm]

Axial Stones 32
PAGE 56

[16.5" x 12" x 6"]
[42 x 30 x 15 cm]

Axial Stones 33
PAGE 80

[20.5" x 12.5" x 16"]
[52 x 32 x 41 cm]

Axial Stones 34
PAGE 126

[26.5" x 12.5" x 13"]
[67 x 32 x 33 cm]

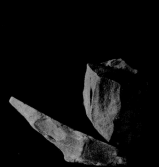

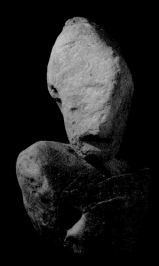

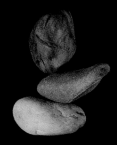

Axial Stones 35
PAGE 94

[9.5" x 12" x 5"]
[24 x 30 x 13 cm]

Axial Stones 36
PAGE 76

[21.5" x 11.5" x 8.5"]
[55 x 29 x 22 cm]

Axial Stones 37
PAGE 60

[9.5" x 8" x 5.5"]
[24 x 20 x 14 cm]

Axial Stones 38
PAGE 90

[13" x 7" x 4.5"]
[33 x 18 x 11 cm]

Axial Stones 39
PAGE 110

[12" x 7" x 6"]
[30 x 18 x 15 cm]

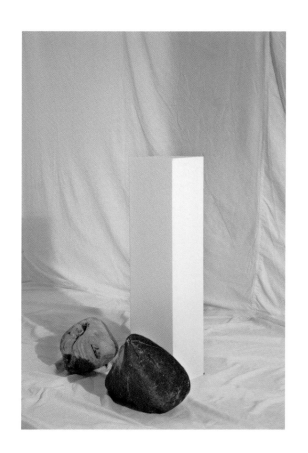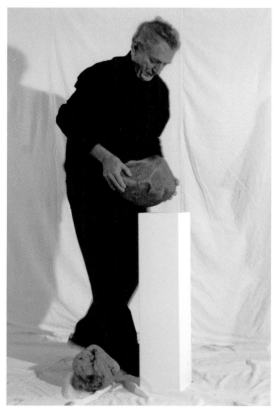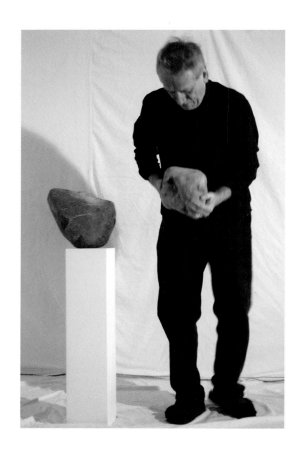

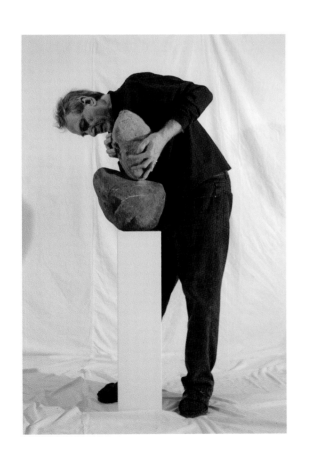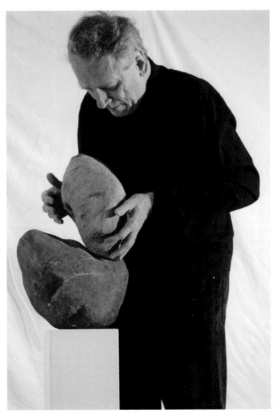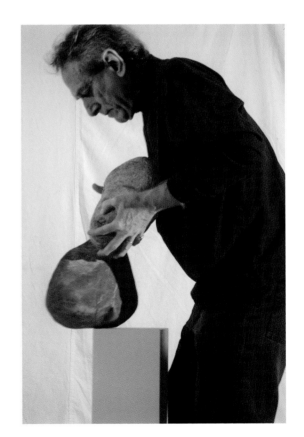

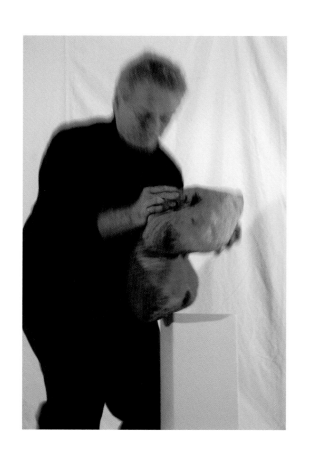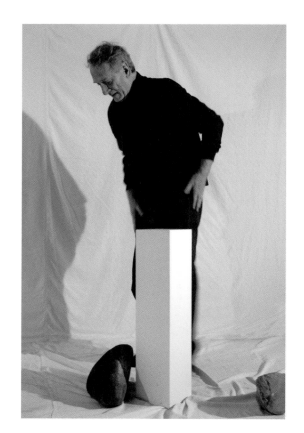

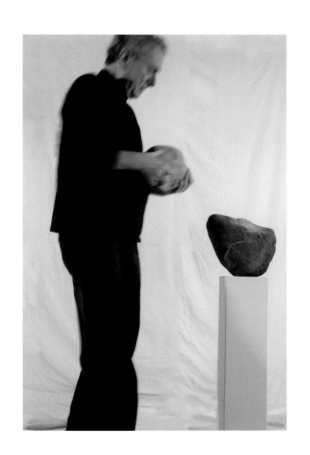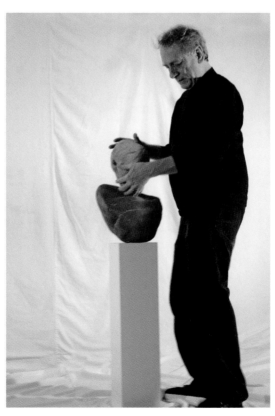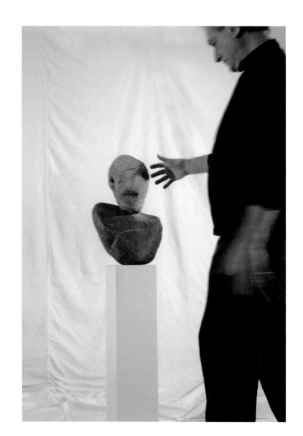

contents

Gathered into one another's company, George Quasha's *Axial Stones* establish a zone of riveting stillness. Yet each was brought to that shared state by a history—a tempo of events—entirely its own. It is the work of an instant to spot a likely stone, but it may take the artist days or years to see how two stones fit together to form a single piece. The fitting itself can be quick or slow. In any case, the process follows strict rules: one stone must be balanced on another, at a narrow point of contact, and no adhesive is permissible nor may either stone be modified in any way. The results are astonishing.

At first glance, it looks as if Quasha has found a batch of wildly eccentric natural objects. Then one realizes, with a start, what one is seeing. In each case, not one but two objects have been joined at precisely the point that turns them into a unity. These configurations appear to be sturdy. Yet each is so delicately balanced that the slightest touch would topple it. Their collective title, *Axial Stones,* draws attention to the axes around which all of them must, out of deference to gravity, be organized. Most axes—the axis of the earth, for example, or the crossed axes of a Beaux Arts building—are not only clear but stable and, we hope, permanent. The axes of the *Axial Stones* are different: clear and for the moment stable but charged with an air of contingency. Uninterested in the sort of axis that enforces solidity, Quasha finds ones that look alive with precariousness. Thus he collaborates in a redefinition of art that was launched by John Cage, his favorite predecessor, and might be understood, in brief, as a dismissal of Plato, who dismissed art as derivative.

In the *Republic* and elsewhere, Plato argued that painters and sculptors make images of perishable and earthly things that are themselves inadequate images of imperishable models, ideal Forms residing in a heaven beyond the reach of human intellect. Plotinus insisted that art can show us those Ideas, those absolute Realities, and for nearly two millennia artists adapted his faith to their eras. Though transience is the subject of the Impressionist painters, the structures of their pictures are no less stable than those of the Academics who preceded them and the geometric abstractionists—Mondrian and company—who came after them. As crucial as it is to harmonious composition, that stability does not reveal a transcendent order. Yet it is an emblem of the yearning for transcendence, and it remains intelligible. Plotinus still haunts us with ghostly encouragement to believe that art is representation and the best art represents the highest things.

As the middle of the twentieth century approached, John Cage suggested that a work of art need not be a picture of anything. It can be the trace of an action or the action itself. Early in the 1950s, Harold Rosenberg invented the figure of the American Action Painter. Toward the end of the decade, Allan Kaprow proposed that painters set aside their brushes and enter three-dimensional space as instigators of Happenings. This flurry of art-as-activity was stilled for a moment by the sudden, blunt immobility of the Minimalist object. Then several of the Minimalists and many younger artists shifted their attention to the process of making things. Process itself became the focus for them that it had long been for Cage. Process art, performance art, real-time video art—all these and more freed art from its ancient hope of revealing absolutes. To acknowledge action is to flirt with contingency or, in Quasha's case, to embrace it without reserve. Or it may be that he induces it to embrace him.

To make the *Axial Stones,* he must use two hands. This is obvious and worth mentioning only in light of the process that results in the *Axial Drawings*. When he draws, Quasha works with both hands simultaneously. Dragging the edges of his graphite sticks over the paper in quick, curving motions, he produces elegant swirls of translucent gray. Though these images look as if they might vanish as quickly as they came into being, each is anchored by the presiding line that emerges from the pulse of Quasha's gesture. The *Axial Drawings* bring the clarity of an axis into delicately felt balance with idiosyncratic forms, as the *Axial Stones* do in three dimensions. Of course, the balance of the *Stones* is literally precarious and that of the graphite forms is not. Beyond this difference is everything that the *Stones* and *Drawings* have in common: grace, an acceptance of contingency, and the two-handedness of the processes that generate them. Consciously or not, we gather from every work of art an intuition of a bodily state. Ambidextrously improvising, Quasha endows his work with a limber, responsive sense of the body—his body, in particular, and all bodies, not so much in general as in their specific potential.

Quasha's bodily sense finds its most telling contrast in Leonardo's image of Vitruvian Man, which aligns the human form with the symmetries of circle and square. Invoking the authority of the Roman architect Vitruvius, Leonardo declared that the proportions of the body are not only compatible with geometric form but reflect the structure of the universe. To make his analogy between micro- and macrocosm as persuasive as he could, he depicted the body front-on with a strictly vertical axis for a backbone. This anatomical symmetry reappears in buildings, in city plans, and in traditionally composed pictures—and elsewhere, too, for we like to project our cosmological notion of the body onto the world around us. It comforts us to see our structure mirrored by our surroundings. Yet we enjoy this comfort at the price of a drastic generalization, for Vitruvian Man is an abstraction: no one in particular.

A yearning to transcend one's particular self animates much of Western culture. Or we try to have it both ways, as in Expressionist art, which claims that the way to the universal is through the individual. As I noted, it has only been in the past half century or so that artists have given up the transcendental bootstrapping that began with Plotinus. To put it the other way around, they have plunged without reservation into their particular circumstances. Of course, the allure of the universal persists. Only some artists—really, just a few—have followed John Cage to a full acceptance of contingency. Outstanding among them is George Quasha, whose axial art makes it clear that an immersion in the flux of experience is not a submission to happenstance. For Quasha, an axis is like an intention: a force that, as it generates possibilities, gives them a provisional but intelligible order. Every esthetic advances a hope, for truth or clarity or beauty or whatever. Quasha's esthetic is driven by the hope that possibility will always be open and fresh, never predictable. Thus will our possibilities remain human, thoroughly ours and in no need of transcendental alibis.

—Carter Ratcliff

prologue

This is a book of stones doing something different from what people expect of stones. They stand *improbably*, carried to the edge or thrown into interdependence, and balancing on a precipice of their own making. And they seem to be *of* this very moment, in the viewing, impermanent, revealed as they are, enjoined in a further nature.

I call them *axial*, a word I use somewhat idiosyncratically to draw attention to a certain state of being—*free* being, or being coming into its natural state as free. This said, I willingly acknowledge that this state does not sit well or long in any definition, and indeed it sheds definitions through the force of its further appearance. I seem endlessly to be saying what it is, provisionally, perhaps because it's my bent to do so, or because, as I think, once you get a sense of the axial you can't resist trying to say, or show, what it is.

What is clear is that the axial is not a thing: not a philosophy; not a religion; not an aesthetic; in short, not itself any of the many ways that can be used to understand it. It's more like a space, a *worked* space—an intentional state of awareness in which something unpredicted occurs: a unique *event* resulting in what seemingly embodies its *origin* and yet itself is *original*. At once unchanging and nonrepeating.

I call this result *art* because it carries unprecedented traces of its own generation and inclines to make more of itself. And I speak here of *axial stones* because, well, here they are, and in my view they speak for themselves. It took nearly 2,000 photos to get the small number that make up this book, where the standard was conveying not so much the *object* as the *event*.

What do they say in speaking for themselves? They speak the specific impact they have on viewer as on maker, which may include removing all sense of statement, at least for an instant, a blank mind following startle. They affect the body; they resonate *through* bodies. In some sense they *are* a specific state of resonance. It's almost as if they ask to be seen by the whole body, not just eyes. *Touch* would tell more, but they're far too precarious to permit touch; in fact, they're rather dangerous. Yet the

impact is "toucherly" if only by way of refusal to be touched, and *touching* in the felt lack of desired contact. They stand there in their precarious balance, attracting and refusing. Perhaps they bespeak a sense of *zero*, emptied of everything but their own unlikely emergence—stones momentarily absent of the gravity of stones, while emanating the threat of grave consequences, should one transgress.

The axial is what makes these stones what they are *as* you see them; that is, in the *way* that they appear and in the *process* by which you see them. The axial is what presents them *thus*, at the horizon of their own event. For me, after some years of making them, to experience the event is to be awake at the horizon.

open axis

Sooner or later everything turns, and turning requires an axis, usually invisible. The Earth, the Sun, Jupiter, and people have at least one thing in common—they are bodies that move on an axis, whether *axis mundi* or spine. When the axis is open—that is, released, not forcefully held in place—things turn freely, subtly moving in and out of balance. Keeping the axis open and aware produces the state I have been calling *the axial*. For a human being (used to more or less walking "upright" rather than on all fours) to keep her or his own dynamic axis open requires a certain process of awareness, indeed a practice or discipline. There are many body-centered techniques, both Eastern and Western, for observing and preserving the health of the axis. These techniques somehow focus the senses directly on the axis (as spine, inner column, or whatever), toward discovering its role with respect to what may be considered *the center*. Center as a "dynamism," or perhaps an intensively contained field of motion with feedback, rather than fixture of control or defense.

Art (broadly defined) has the potential to perform such a sense-based discipline of the axial, which could be thought of as a dynamic *self-mentoring* through the "medium" of the physical body. I have been interested in the possibility that when an art develops a disciplined awareness of the axial, its stance may be more "naturally" open to continuous change and discovery, perhaps deliberate innovation as well, but without necessarily valorizing innovation as such. Whether or not this is a generally applicable notion, I have found it to be a powerful way to think about art in relation to principle. It seems that the axial sense of art thrives best in an environment that values the unexpected, the unprecedented, and the radically new (which may or may not apply to the "avant-garde" sensibility). Joy, rather than, or at least equal to, fear before the unknown and the unnamable.

It also seems to follow from this way of thinking that, for an artist to enter into "the state of the axial," she or he must be willing to be somehow "rediscovered"—or to be in such a state of flexibility that continuous change becomes normative. To some degree this describes the state of art itself, or at least what one might expect from art. After all, "axial" could be another name for "verse," what develops through continuously "turning." Yet there is something to be said for emphasizing a state of *further axiality* and its relatively high degree of precariousness. In this view the axial is, by definition, quite unstable, if axis is understood in relation to actual physical environments, always in flux. The "art" part emphasizes what might be called a *willing instability*.

Contrary to a "common sense" or otherwise consensual view, this instability is understood, implicitly if not always explicitly, to be fundamentally healthy. And, notwithstanding an intelligent mistrust of claims for the therapeutic value of art (especially if the claim promotes one art or method or style over another), we might entertain a non-invidious suggestion of

benefit connected to the axial, the free state, an activated and activating state of possibility. This is tricky business, to be sure; and nothing is riskier—or more obviously contrary to the axial!—than privileging one set of values over another. And claims of "a deep and ancient wisdom of art"—a tempting notion in certain moods of enthusiastic embrace of possibility—too easily lead to Golden Age nostalgia, metaphysical revival, dogma and, frankly, a rigidity in the very insistence on flexibility. This would be to promote an "ideal" state, rather than inquire into what in any given instance is *optimal*.

"One law for the Lion & Ox," wrote Blake, "is Oppression."

principle and origins

My approach to presenting the axial stones in this book is personal in more than one sense. Most directly, I try to give some account of the experience, in the form of stories and discussions, of how I (and others) found the stones and what happened in the process of realization. At a remove from the hands-on aspect of experience is the thinking that somewhat guides or helps sustain the work, relating it to many kinds of inquiry (scientific, philosophical, social, political, psychological, ontological, and so on), and clarifying its integrity. In this book I have chosen to give only the briefest account of the development of *axial think-*

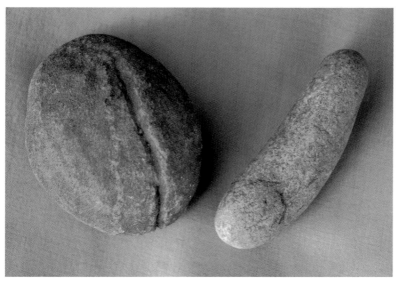

Two stones found in close proximity by Susan Quasha at Walden Pond, mid-'70s, resembling the lingam and yoni objects of Indian Tantra, an instance of attraction between stones.

ing, as indeed of its partner, *axial poetics*, for the obvious reason of space and focus. This is a book about axial stones. Still, while there is virtually *no* "detached" thinking during the intensely focused physical realization of stone works, which have a mind of their own, the space, as well as the context, that creates the energetic field of the works is very definitely *held* in part by thoughtful focus. And so we have the present discussion.

This thought focus is connected to the art focus, particularly in the definition and development of art boundaries. But the *practice* is not the product of an intellectual enterprise. And this partly has to do with the origin of the work and the way the axial stone process was discovered. I relate the details later in the section called *stonebusting;* my point here is that the process developed out of pure attraction to the play of the stones in their precarious balancing. Once it began, it furthered itself, which most simply means that I couldn't keep my hands off stones, first small ones and then larger ones. It was as strong as any erotic obsession, and in fact seems rather similar in intensity. And the actualization of the process led to meditation on its many meanings.

It quickly became clear to me that the balancing aspect of the work had a lot to do with the relaxed alertness and dynamic alignment in the practice of t'ai chi chuan, which I had already been studying for some two decades. In the martial practice of push-hands one maintains a certain awareness within one's own body, even while focusing inside the energy field of one's opponent and keeping a sharp eye on his external movements. This double awareness of self and other is also a sort of *resonant alignment by field* — a subtle dialogue between one's own axis and that of the other person, as well as an open, lively, and panoramic sense of *surround*. Even balancing very small stones, which is how I began and continued for at least a year, I could see the connections with t'ai chi, as well as with another interest of mine, hands-on therapeutic bodywork, which emphasizes responsive listening.

These were discoveries, both sudden and gradual, made within the axial stone process. I saw them as manifestations of principle, which allowed me to study them both intrinsically and comparatively with other disciplines, and this awareness in turn strengthened and deepened the practice. It also led me to understand a possibility that I call *principle art*.

The principle of a principle-based work is not necessarily *prior* to, in the sense of "leading up to," the practice. Obviously the principle had to already be there before the practice, but not the discovery or the awareness of it functioning as *motivation* for making the work. This might be one of the many differences (amongst certain similarities) between *principle-based* art and *conceptual* art. (In my view, some conceptual art may be equally well, perhaps even better, thought of as principle art.)

I want to acknowledge kinship with the notion of a *conceptual* base and, to be sure, some conceptual art (including its historical predecessor, Henry Flynt's "concept art"), but I am more interested in the notion of *principle*. In many accounts by self-described conceptual artists it's clear that the concept precedes a given practice and that the resulting work may be considered the definitive instance of the concept; this fact may obviate any further realizations of the concept. More broadly, the work is the outgrowth of a defining intellectual focus. By contrast, the awareness of the operative *principle* may or may not precede the practice, and, as I suggested, the principle may first become evident within the practice. It follows that a principle has no definitive instance and is not defined by a given manifestation; in fact, further instance is necessary to realizing the truth of the principle. New works may become inevitable as a consequence of the *declaration* of principle.

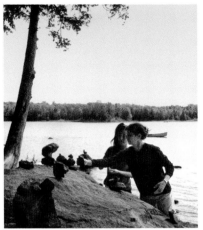

Lake Harris, Newcomb, New York, in the Adirondacks, 1997, Chie Hasegawa and Susan Quasha balancing stones with George Quasha (taking photo).

So if there is a declared principle of axiality, unlimited new events—for instance, axial drawings, axial music, and axial video—are called forth. A principle, unlike a concept, cannot be exhausted. Nor, in theory, would it be alterable, although the *expression* of it evolves. I think of the axial as a further instance of a *life principle* in that it is at once self-regenerating and nonrepeating.

I have to acknowledge the difficulty of explaining how such a notion of principle is not merely another facile intellectual pretension—a gratuitous abstraction that one believes in and wishes to represent. And admittedly it's possible for such a notion to become another trap for the self-serving "art ego" in search of self-justification. Perhaps the only real protection against self-delusion is the actual charge and livingness of the work produced. Yet this too of course risks taking refuge in an arena of aesthetics and artistry, the lure of metaphysics and some form of "ideal." At the same time, any effort to avoid extremes by choosing sides (e.g., "process" over "product" or "aesthetic object"), or avoiding choice, still does not eliminate the infamous "torments of dualism." There are no guarantees, and I'm not suggesting that the axial principle resolves fundamental issues. On the contrary, it's an approach to moving amidst unresolvable polarities.

liminality

I work the notion of liminality as a way of keeping present within the dynamic of continuously appearing oppositions. "Being at the edge" in the sense of *threshold (limen)* can mean many things; in axial composition it takes on a sensory precision. One becomes aware of a certain tautness in the engagement with material, a surface tension, which can also be registered as a *tuning* in the body. This experience may contribute to awareness that is *physically alert* to the medium. Touch has tone and an intensity of focus that can transfer from one medium to another. Attention here thrives on otherwise troublesome contraries by not taking sides and remaining instead in the tense zone between. This somewhat special sense of liminality (a word that is used in many ways these days) implies *a conscious choice to work at the edge and accept the energetic advantage of precariousness*. Actually, one does not avoid or fall out of touch with either contrary, but instead retains, so to speak, a live connection with both. What happens in the middle is itself and new.

Flexibility in the choice of mediums is an important advantage of working from principle, and the axial in particular. A grasp of the principle allows one to approach a new medium openly and in a spirit of inquiry, rather than would-be mastery. It seems that a new material is a fresh and living matter; one wants to find out what it has to say. Perhaps it's like a certain bandwidth where one tunes in to find out what's going on or what might come through, once one puts out the call. One might have faith in the rightness of being attracted to a certain medium or even multiple mediums—stone,

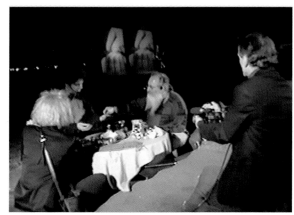

"Site Cite," mixed media performance, 1993, Long Beach Museum of Art; from left: Joan Jonas, Gary Hill, Charles Stein, George Quasha.

"Two Ways at Once (Deux Sens à la fois)," mixed media performance, 1998, Musée d'Art Contemporain de Montréal; from left: Gary Hill, George Quasha, Charles Stein.

"Spring from Undertime (Awaking Awaiting)," mixed media performance, 2000, On the Boards, Seattle; from left: George Quasha's Preverb on screen; in view from left: Charles Stein and Gary Hill.

graphite on paper, words in the voice, video—and willingly assume that one will act as attractor in a field of possible activity. This way one can project a certain natural force, as a spur to unprecedented happening, without exerting overbearing control. It's as though one's own identity dilates in order to situate in a field at large.

When working in multiple art mediums, or practicing different art forms, from a single principle, these mediums/arts emerge in ways that are liminal to each other. They affect each other in the very difference of their articulation of a common principle. For many years I identified my core art practice as poetry, yet I was always interested in the fact that language, although essentially time-based, disposed itself spatially as well—as hieroglyphs, ideograms, pictographs, sign language, written or printed texts, emblem poems, concrete poems, signs, animation, film or video texts, and so on. Any spatial/visual language nevertheless unfolded in time and redisposed it in a way peculiar to each type of manifestation. The reading time of a hieroglyph, an ideogram, a book text, or a video text offered its own dimension of possible language. More radically, walking across a space while talking, for instance, engages syntax at the level of physical body-in-time, and might show emergent "meaning" as synapse as much as syntax. When Gary Hill and I began our long interaction and collaboration in the late '70s, we cross-pollinated language, video, and performance arts, a process that is still evolving between us and includes equally our other main collaborator, Charles Stein. Practices of axiality and liminality came naturally to us, and many possibilities emerged from a common matrix. Similar germinal matrices have arisen with other artists—for instance, the composer/writer Franz Kamin played a major role in this regard—in which normally separate arts became interdependent and reflexive. This sort of intense collaboration foregrounds the fact that the arts have always influenced each other in profound ways, yet there is a difference when one consciously embraces the liminality and works the edges of the arts. One has transformative insights that start out with notions like "it's *all* really language" or "music" or "performance," and then one sees the work moving out into unnamable complexity.

Working "poetically" with a statement in language in such a way that the meanings go in and out of equilibrium, moving toward, say, a *significant shift* in syntactic force, in my experience is not all that different from setting a stone upon another stone and letting it turn on multiple axes until it finds a *still point*, whereupon sudden new form shows itself. It can provoke all at once a release of energy, a startle response, and excited waking up—and feed the fires of *more of the same*. Axial stones can be viewed in terms of poetics. Axial poetics can be language sculpture, working with the *material* of language as *elemental*.

elemental opening

One gets a sense of the elemental in relation to specific material. What constitutes an *element* seems to be an open category—we say *earth, air, fire, water;* the Chinese (perhaps due to the lobbying of ancient artists) add *metal* and *wood* and somehow leave out air; the Tibetans add *space* to our four (some call it *mind*). Why not *stone?* Why not *sound?* And why not *language?* The elemental would seem to be the site where, in manifest reality, you get through to the most essential, access to the irreducible in a *lived* world. An element, at this level, is something you cannot imagine the world *without.*

Axial poetics, the earliest of my practices, late '60s, derived a sense of "torsional syntax" from Blake's Illuminated "prophecies" *(Milton, Jerusalem)*—that is, syntax that takes a reader through complex states of attention as it moves along. I was drawn to what the poet Robert Duncan called "the living changes of syntax" in which he found a "snake-like beauty." His stance, like Blake's, was as a "servant" of the art:

> I ask the unyielding Sentence that shows Itself forth in the language as I make it,
>> Speak! For I name myself your master, who come to serve.
>> Writing is first a search in obedience,
>>> *(The Structure of Rime I)*

Whatever the medium or art form, this is a view of art as a physical as well as mental practice inside a *material* regarded as living and revelatory, and indeed elemental. For me the primary, originary medium was language both as text and as sound, manifesting first in textual works.[1] The work becomes *axial performance* initially as "sound poetry," developed in collaboration with Charles Stein in the '70s, in which performative dialogue worked between sound abstraction and semantic figuration. Our work together in turn became intermedia performance with Gary Hill from the late '70s.[2] Thinking about any actual performance it seems academic to separate one medium or art form from another, or one person's work from another's. The "component parts" include language/text, video images and sequences, physical body-movement, multi-screen simultaneous projections of prerecorded and live performance elements, a range of sound (including "axial drumming" on a snare drum), multi-language utterances, live projected drawing in air, and so on. One experiences in such performance a single complex phenomenon of continuous new diversity that produces itself *further,* or what in complexity science might be called *a collectively autocatalytic system* (or *field*). Very different art entities discover one or more common axes and spin out unprecedented time-space events; they make more of themselves without relying on repetition. You could say that each moment gives rise to a unique life/art liminal object.

stone/drawing/music

My experience of *axial drawing,* especially as drawing on paper with graphite, shows the liminal connection between mediums as well as any other art. It's an art whose flow is sustained by a special vigilance within its process of engaging elemental material (graphite on paper), and it is focused so as to track unprecedented emerging form. Like axial stones, axial drawing has a relation to both the martial arts practice of push-hands and subtle bodywork, where one remains in *listening posture at the precise point of physical contact* and follows an emerging event *without exerting direct pressure.* This is a difficult idea for artists who have been highly trained in drawing, where point-specific control and precision are highly valued. The quality of touch between the graphite and the paper tends in axial practice toward the *receptive,* as though the graphite is receiving *surface guidance,* perhaps somewhat the way a surfer is listening to the wave beneath. In this approach drawing is a wave phenomenon.

There is here very little attention on technique, which is regarded as, literally, heavy-handed, manipulative. Emphasis falls rather on the changes in oneself through the practice, how eventually there is a reversal of reflex, a sensory inversion. One comes to a discovery of objective surrounding as something like a *zero world,* empty of predetermination, yet resonant.

1. Including: *Amanita's Hymnal* (1971), *Magic Spell for the Far Journey* (1971), *Somapoetics* (1973–1980), and *Giving the Lily Back Her Hands* (1979), *Ainu Dreams* (1999, with Chie [buun] Hasegawa), *The Preverbs of Tell: News Torqued from Undertime* (1998–2006).

2. Beginning at the Arnolfini Art Center in Rhinebeck, New York, 1977, and Barrytown, New York, and registered eventually as single-channel video in *Tale Enclosure* (1985).

Our three-way collaboration became full-scale multimedia performance, for instance, in *The Madness of the Day* (1993, Museum of Modern Art, Oxford, also with Marine Hugonnier), *Site Cite* (1993, Long Beach Museum of Art, also with Joan Jonas), *Two Ways at Once (Deux sens à la fois)* (1998, Musée d'Art Contemporain de Montreal), *Spring from Undertime (Awaking Awaiting)* (2000, On the Boards, Seattle) and *Mind on the Line* (2004, Poland and Czech Republic, also with Dorota Czerner and Aaron Miller).

One somehow manages to approach this facticity palpably, with sheer listening intensity—listening, that is, through the hands. Accordingly onecannot hold a model or ideal in mind, yet one tries to stay alert for the optimal, which is openly relational and concretely connected to what is at hand.

The drawing prefigured the stone work, in that I was drawing in the axial way (no effort to represent, no control over the line) a decade before working with stones. But then the stone work refigured the drawing, when I noticed that the action of moving the stones on a pedestal left a trace drawing scratched into the surface, a two-dimensional record of a four-dimensional spiraling event, something like a reverse musical score. This led to a moment when, picking up a small stone in Barrytown, I flashed on a practice of dipping the stone in ink and letting it draw. It produced drawings rather like the axial stone traces—a further scoring.

The sense of music is always present in axial work. There is the sound of the stones grinding together as they rough out the move toward fit. And graphite on paper, frictively sounding the paper to feel it through. Feedback from the medium is both tactile and aural, and could be measured in "excitable decibels," as though the sound is what is in excess of physical touch.

This experience of inevitable music made me wonder what an axial music would be. I speculated about this with the composer Benjamin Boretz,

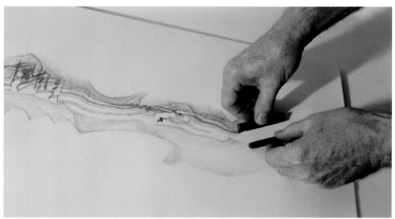

Above: Axial drawing, two hands simultaneously and independently using graphite sticks. Facing page: Axial drawing, graphite, two-handed, 18″ x 24.5″ (45.7 x 62.2 cm), August 8, 2005.

who had published in his magazine *Open Space* the first version of my pieces on the axial ("Preverbs," "Axial Stones," and "Axial Drawing"), and he challenged me to write about axial music. I said that, while I felt that I had seemed to find axial music in some of his work (and later I thought of composers as diverse as Morton Feldman, Pauline Oliveros, Franz Kamin, Cecil Taylor, John Beaulieu, and Marilyn Crispell), I could only write theoretically about something that I was doing myself; and I was not now making music. Shortly afterwards I noticed a disturbing sound in the back of my head, and I eventually interpreted this as an involuntary response to the question; once I had thought this the sound went away. Soon afterwards I went out and bought a snare drum—the only instrument I had seriously played in my teens (in my high school orchestra and marching band in Miami, Florida). And I began practicing every day with a single goal: to subvert the art as I had learned it and thereby allow the axial to arise in the emptied space. I began to reach this level when I allowed myself to break the rule of only one or two beats per drumstick; I allowed three or more, indeterminately, and that took me beyond control and outside the scope of my training—I was freed. In this apparent *chaos,* rhythms began to arise of their own accord (autocatalytic), and I learned to follow them without trying to sustain them. Then I began to hear what I had not heard before.

It related to listening in drawing and stone work. Yet the strangest thing was the impact it had on the drawing. One day in August of 2004, as the first signs of axial music were showing, I played excessively, until I noticed that my two hands were actually getting hot. I stopped and just felt the sensation in the hands: they were equal, as though I were no longer right-handed. What if the two hands could draw simultaneously? Then I remembered a dream reported to me a couple of days before by a friend, Jenny Fox, in which she saw the drawings as they had been, except that there were two figures on a page—something that had never been. And I also remembered Susan Quasha's cryptic remark, when I had asked her advice on whether to buy a drum: "I think it'll help with the drawing"—words that had sealed my decision to start drumming. So now I was excited at the strange prospect of drawing with both hands, and I immediately picked up two graphite sticks and let the two hands draw independently and at the same time. The results were far beyond any expectations, and this was the beginning of a new practice. Since that moment I almost always do two-handed drawing when using graphite.

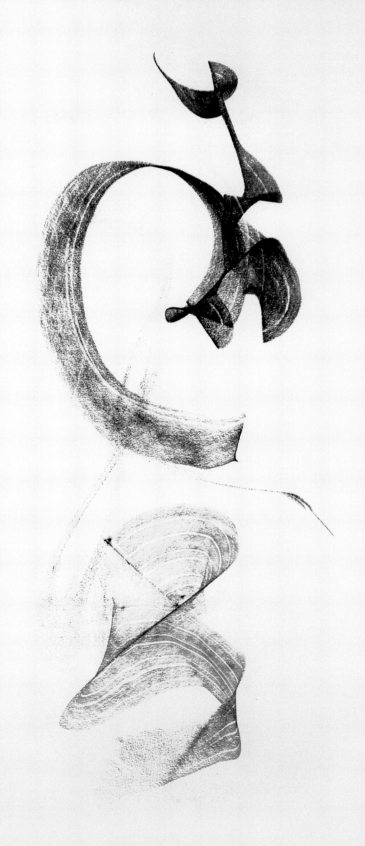

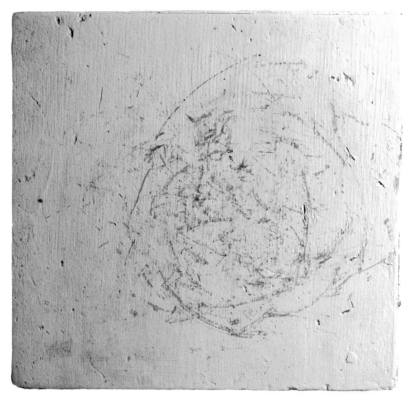

"Trace drawing" scratched into the surface of a pedestal where axial stones left a 2-D record of a 3-D spiraling event.

the resonant personal

I said earlier that my approach to presenting the axial stones in this book is personal in more than one sense. Now I want to add what to me is the most important sense of the *personal*. It's well known that the origin of the word *person* is the Latin word for mask, *persona,* and *personando,* the act of sounding through the mouthpiece of the mask. So *the personal is the act of speaking that occurs at a created site*. I can say different things on different days about the same thing, and mean it. Does one saying supplant another? Not necessarily. A true saying has an ontological necessity, as when we finally get something said and feel that life can now move on. It should be self-evident that living language does not follow logical laws; contradiction is a mood of thinking.

Poetry could be considered the art form of language-site-specific saying: that is, at this point in evolving reality *this* gets said, and that changes everything, as an act of presence. And a poet would be a person who knows this in her/his bones and does not repress the urge to let language speak out of itself, *now,* beyond a concept of *itself*. This is an axial act, a release into the center of the moment of saying in which anything speaks. Each act is *personal to itself*. Stones speak, and axial stones constitute the act of speaking in stones—not a long way from *tongues,* because we just register the speaking, with a shiver up the spine, bypassing all understanding. Who needs understanding when we are already standing in *undertime?*

Meaning here is in excess of cognitive grasp.

undertime / still point

What guides? Compositional sense, no doubt, but in a modality that includes a certain *unknowing*—a precariousness. I give the name *undertime* to accessible basic atemporal reality as *level*—in place of "universe," "zeroverse." I must resort here to a notion of something mysterious, something that would serve as source of temporally emergent and "spontaneous" possibility. I'm aware that undertime cannot be perceived directly, yet it shows through as a *pulse,* which, however, is variable and unpatterned, and which one can follow within oneself or in the work at hand. Follow what? Strange to say, an *actual impulse,* one's *own* impulse in the contact with medium, as if one is becoming the amplifier of a "thrown

The double action gave the feel of emerging four-dimensionality, the birth of a complex sphere that is always there when working with stones—as if fashioning a bottle that fits the stones in their balancing. It's an event of the between. One becomes more aware of the space *around* a touch, a mark or a line—the all-important *first mark* that sets in motion the fate of the drawing. Even a so-called point is a line, a very small line, and a line in this actively curving multiverse is a *wave*. And the movement has a pulse, like a living being, which the art entrains to. This surrounding space is not entirely spatial; it moves through degrees of energetic intensity and temporality; one is tempted to speak of a *resonant surround*. And it has a certain multiplicity that, once recognized, pulls one away from attempting to create unity as such. Instead, one waits for a sense of completeness, where pulsation ceases to compel further action. Yet the urge remains, embedded in the liminal object, where the traces of fully sounded friction become the attractors of further viewing.

voice," a ventriloquism of the emerging entity, the work itself—of stone, drawing, sound, language. The recognition of impulse requires a certain alert openness, a species of "beginner's mind" or attitude of "non-mastery" of one's own means—an attentional dilation before what is at hand. Ordinary momentum and familiar voice, however attractive and desirable, can distract from *optimal attention,* which must center in the actual moment. So one learns another way, a way with the strange and unknown, with which one maintains gentle contact.

"Feeling a pulse" seems easier than in fact it is, because our sense of physical pulse is based on the simple medical practice that resorts to a normative and quantitative, ultimately statistical, model. Other practices of reading a pulse, less familiar in the West, for instance the Oriental Medicine approach, are qualitative and relative to the individual organism's *array* of pulses. There are multiple pulses even of the blood. Breathing is a highly and quickly variable pulse. The craniosacral fluid pulses several times slower than the others, and reading it requires a very special listening focus. So an organism is an immensely complex field of variable and interdependent pulsations, in which a sudden pulsation may seem more like a spike or unique irruption than a moment within cyclicity. It would seem obvious that art composition—a drawing, a musical composition, a poem—is from one angle a projection of the artist as organic entity, and potentially can imitate, embody, or otherwise be governed by one or more of the pulses, or even the *field* of pulsations. "Beneath" the array is the undertime that on one level, I am theorizing, stands for the possibility of pulsation itself. Axial listening in this sense rests, indeed *resides,* in the zero point of undertime in such a way that it can entrain instantly to a sudden impulse—an impulse that, originating through such radical openness, carries something like raw possibility within it and is originarily performative. Something truly new holds the focus. Something so clearly itself that it leads to a further listening, attracting its axial music.

The opportunity for originary awareness in another vocabulary is the *still point*—a notion that finds its defining moment in T.S. Eliot's "Burnt Norton" *(Four Quartets):*

> At the still point of the turning world. Neither flesh nor fleshless;
> Neither from nor towards; at the still point, there the dance is,
> But neither arrest nor movement.

Its widest use at the moment is probably in bodywork, especially Craniosacral Therapy, for the gap or pause induced by temporary suspension in the fundamental pulsation of the body (the craniosacral rhythm in the flow of the cerebrospinal fluid), which can mobilize the system's inherent ability to self-correct and, indeed, reconfigure. I like to think inside such technical vocabularies for the richness and complexity of their experience-based theory. In my practice with stones, the still point is the space in which the axis shows and sudden balance becomes possible.

In *principle,* then, axial poetics allows for *interruption of momentum* so that gesture is allowed to pass freely through the medium, an incursion that radiates. And there is a sustaining theory of the principle as *a possible poetics of any moment*—a speaking from the actual instant, a zero-point voice.

Such a notion of immediate orientational adjustment in a specific changing environment can help us think what makes a line (a vector) move, turn upon itself in the frictive engagement with a medium, and produce a state of open configuration.

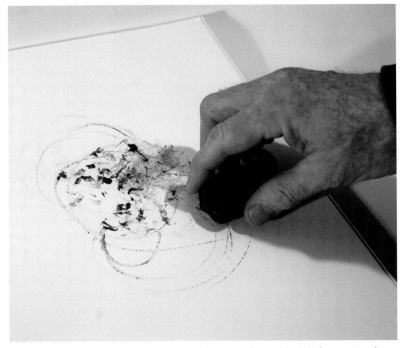

Axial stone drawing, using a found stone dipped in ink (two colors), resembling the trace drawing on left.

GQ performing axial hand movements, called Somamudra, developed c. 1972 in relation to "poetic torsion" in *Somapoetics* (Sumac Press: Fremont, 1993).

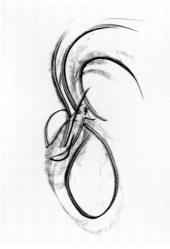

Axial drawing, graphite, two-handed, 18″ x 24.5″ (45.7 x 62.2 cm), August 8, 2005.

configuration

The apparent and in some ways mythic incompatibility of figurative and abstract (in the sense of non-figurative) is a persistent theme in art, even among many of those who disavow a preference. It shows up in the way people dismiss certain tendencies on the basis of historical development, which often comes down to the fact that "taste" has changed. (We used to say *representational vs. abstract*.) I'm not very interested in the question where it becomes a matter of critical or curatorial fashion; however, I *am* interested in the way the tension between figuration and abstraction (the non-figurative) is a permanent feature of perception and cognition. It may be that any given moment is in part defined by how much we hold to a certain gestalt; that is, how we focus experience. What devolves from this *hold* on emerging shape may depend on the tightness or looseness of the grip. And I suspect that art is a primary teacher in this matter of human perception/cognition and its potential for alert flexibility.

In my practice of any axial art, I am aware of keeping the work *ahead* of figuration and representation. It's as though the emerging entity (stones or drawing) moves *away* from coherent viewing, that is, where "coherent" implies a holdable form or gestalt or other consistency in making sense. It seems that the work's way of coming into being is first of all a material event, something happening within specific materials; and it follows that it must somehow *inhere physically,* as *matter,* before it claims a shape. This puts the work some distance outside the distinction *figurative vs. non-figurative*, in that at any given moment it is standing or

else is moving along a continuum between the two. It may dwell precariously at the edge of one or the other—and then pull away.

I have come to call this liminalist approach to art *configurative,* which is ever at a threshold between figurative and non-figurative, or, from another angle, inclusive of them. In this view figures come and go, catching attention with a momentary will of their own, then letting go of figuration without notice, without formal commitment, and without the artist's permission. *Making* the axial stones (or drawings) and *looking* at them can be quite similar in this respect—there is a sense of figuration that gives over to the field of patterning/repatterning, with a certain internal rhythm or *pulsation*. Somehow they are animate, animating, self-animated. They trace their own time, as if keeping a story hidden. As a record they are barely there. Or what's there is a trail: traces of their time, bare awarenesses in timed space. There's some kind of dialogue between form-seeking elements, the interval between them, and their absence. What they *retain* is bodily memory of the precarious (yet precious) process of self-generation.

This sense of the space of configuration seems to ask for a continuous renewal of both experience and critical perspective. I have found it useful to think of the Japanese notion of **ma,** a *natural distance or time-space between*, which implies respecting the open spaces around and between things. Such a distinction seems to soften the hold on perceptual objects and stand back from the sense of form that defies empty space or otherwise dominates its surroundings. This does not mean particularly preferring the appearance of empty space over crowded space, which would be to favor one aesthetic over another; space can appear very filled-up and yet retain a sense of aliveness in the space itself. Any visual incursion in the flow of a field creates its own special time that carries over to the "area" around. Together the incursive event and its surrounding show time itself as something created. So neither the elements of axial stones/

drawings nor the works themselves are "forms" but, more accurately, neighboring happenings/markings in some state of mutual realization or of cohabitation in a specific place. Likeness *draws them* close together; difference keeps them distinct and in a certain tension. Such tension can lead to further attraction and new registers of formal eros. A kind of natural mystery shows in the fact of interdependent integrity.

zero set

I say that the axial is a *principle* in that it embodies a primary or "first" truth, which is there before any of its "uses" or circumstantial appearances and applications. Or to say it in keeping with its axiality:

the axial stands in its event before itself

Perhaps calling it a principle is a way of saying that it has no category. I like to think this, because it means to me, as poet, that it belongs to the realm of poetics, in the sense of the *necessary provisional.* And I understand this provisional state to be the *open domain of non-definitive saying that performs what it addresses*—the *performative indicative.*

So I can say: the axial comprises a *zero set,* in that it is not a member of its own set. Yet that set, which is defined by the existence of the axial but of which the axial cannot itself be a member, is necessary for its principle to inhere. Hence its double nature: essential and impossible. If nothing else, thinking in this way about the axial helps sustain the attitude needed to do the crazy work that comes out of the axial state—essential and impossible things.

The *stones,* for instance, are such essential and impossible things. From ancient times when apparent earth entities have taken hold of the mind and made otherwise reasonable people do strange things, one has spoken of *possession.* I consider the axial to be a non-coercive evolution of some such "holding"—"higher" in the sense of *freer.* Notions of possession and axiality are, in fact, incompatible. Yet I do acknowledge that something takes hold when I'm working the stones—takes hold, that is, of or through the medium of stones—not *me,* as isolated entity, because I'm barely there. And not an "alter-ego." Rather, a certain state of connectedness between the focus that is *myself* and the emergent appearance that is *the stones.*

To say that the axial is a principle has an impact on the possible meaning of principle itself. This is a curiosity of the axial, that it performs an incursion into anything to which it applies; that is, to think *axial* in relation to something (stones, drawing, the view of it as principle, etc.) alters thereafter how one views stones, drawing, principle.

So what does it mean that principle is *axialized?* It means that principle is itself axial. Axial is not simply a word representing the phenomenon; it is the event of phenomenal axiality, the experience of freedom in the axis. To declare something axial foregrounds both the *substantial* (the physical event of an axis that disposes something in space, e.g., stones, marks, words) and, in the same moment, the *insubstantial* (the freedom from substantiality and all fixity).

To speak of the axial creates a "verbal object" that is both a word and a real-world event, which constantly changes/evolves. It calls into question both word and object, even as it sets them in a new relation, modifying both. Accordingly, to invoke the axial, on one hand, is an empirical and positivistic act that names a "provable" event (something happens that is observable, perhaps even measurable); and, on the other hand, it is a magical enactment of verbal and attentional force such that the thing designated is transformed.

Axial stones float freely in the time of viewing, as the thought of it floats freely in this time of saying, and carries further, to an edge of itself....

The axial statement is an example of *itself,* an axial event at the level of poetics, a reflexive act of speaking that unpacks the word "itself" (as well as the more abstract notion of "the word itself"). Anything said, any indication, has consequences. They range from grave, as in *gravity,* to lightened, lifting, even uplifting, as in *levity.* The latter may be seen as expressing a further consequence of release, precipitated by a principled surrender to gravity through an open axis.

beauty = precarious x optimal

Two pages following: Axial drawings, graphite, two-handed, 18″ x 24.5″ (45.7 x 62.2 cm), (left) August 28, 2005; (right) September 18, 2005.

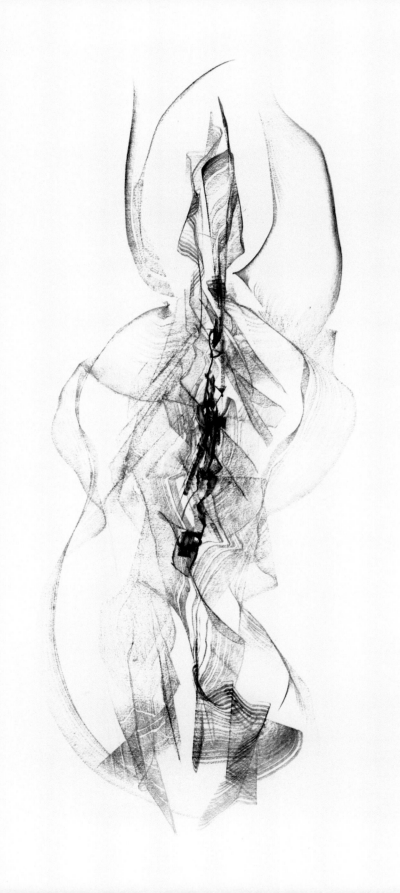

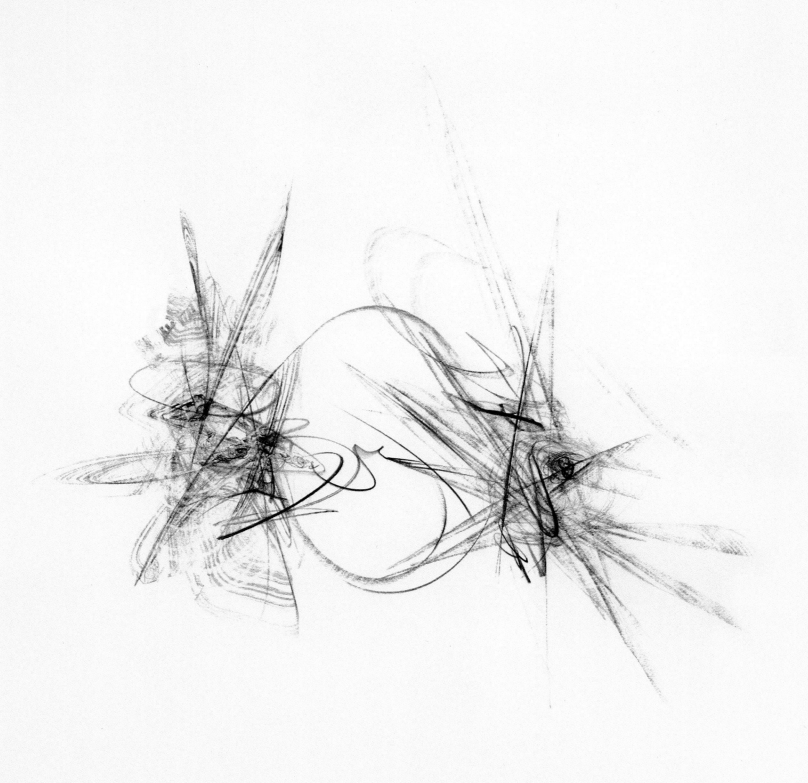

beauty = optimal x precarious

a stone at the edge is still happening

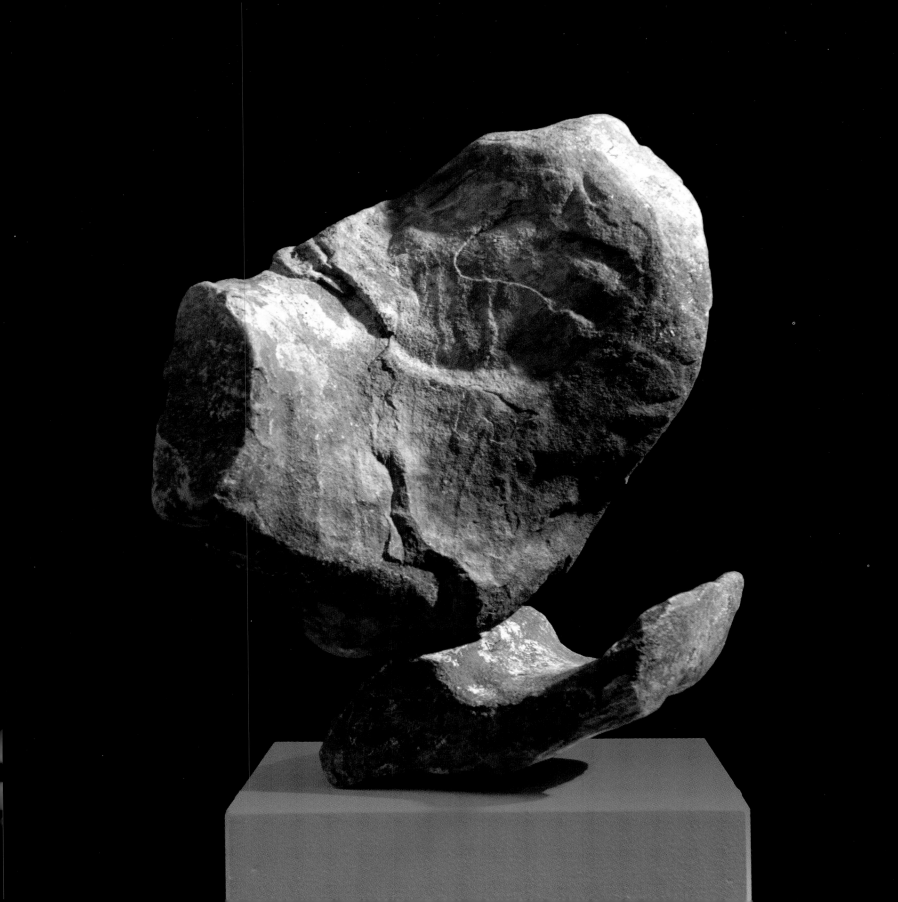

stonebusting

I have never noticed that stones come naturally to my hands. Fortunately I've spent many years around a person who attracts stones effortlessly; I probably never had an interesting relationship with stones until Susan Quasha began putting them in my hands. So I could be a lazy fan, relying on outside intervention to set up the attractive force: the sense that the act of *finding* the stone was an art event. Susan's sense of stones—indeed small things distributed randomly on the earth—has the attention normally reserved for living things, precious creatures. I learned from her that there are secrets of minute touching that call the eye out to the object. This sort of artist's work is found "blowing in the wind," and rarely celebrated.

Balanced stones as such have never held any interest for me. It was a very specific event that created the field of awareness that I call axial stones. Another artist of the nearly invisible, Chie Hasegawa, showed a relationship with stones that was eerily similar to Susan's. Sometimes they found the same stone! Once when we were walking the long rocky path back down from the water-falls at Bash Bish Falls in the Berkshires, a site that would yield many great stones over time, Susan stopped, appearing to stare down at specific stones along the path, and excitedly said, "Look!" I saw nothing but a lot of nondescript small stones until she picked up a particular one that was indeed amazing when held up. At that moment Chie said, "That's my stone!"—a strange thing to hear under the circumstances, until she explained that she had found it on the way up the mountain two hours before but apparently dropped it amidst the thousands of stones of similar size. Forever after this was called the *twice-found stone*.

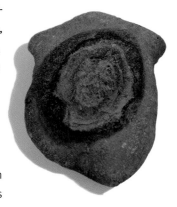

The twice-found stone.

On another occasion Susan showed me a strange and impressive small heart-shaped stone with vertical markings which she said she had just found, and I said, "Are you sure that this isn't Chie's stone?"; she did not take very kindly to the question. I called Chie, who looked at it, then went upstairs and returned with a virtually identical stone, found a couple of days before.

Chie's work made use of things she found almost anywhere; she did things with them that I had never seen anyone do. One recurrent finding was stones with natural circles on them. I watched her reach down and pick up an ordinary looking stone, and the hidden under-side would have a vividly distinct circle. This happened pretty often. One day she showed us two of these stones each about the size of the hand, and she balanced one stone on top of the other, a little off center. This struck me forcefully. I looked at it a long while, and then I asked her permission to touch it and maybe move it slightly—an intrusion that normally

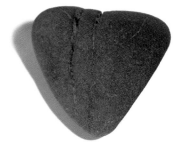

The twin heart-shaped stones.

I would feel reluctant about, but now for some reason didn't. She agreed almost too quickly, as if it didn't matter. I moved it further from the center, to a more precarious point, and I felt a thrill pass through my body. Something had happened; I had somehow changed.

From that moment I couldn't stop touching stones and moving them into precarious relationships. Stones started coming to me; always the kind of stones seemingly appropriate for balancing. They would sit around for a while but sooner or later they would get involved with other stones.

During the rest of the year I balanced small stones on the dining room table (which still shows scars of the process) or any handy surface, and I had barely even a fantasy about working with bigger stones. The original inspiration size came in relation to Chie's one balanced stone work, which I call AXIAL STONES 0, and I stayed well within that size. It wasn't until the event of AXIAL STONES 1 that it all changed, dramatically.

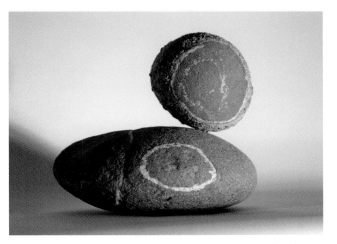

Chie Hasegawa's original work I call **AXIAL STONES 0** (1997).

I would even speak of that night as life-changing. What would become the upper stone of the present work had been lying around for weeks. I had found it on an outing with Susan and Chie along the shore of the Hudson River at Tivoli, and the decision to take it home puzzled me. It seemed both awkward and on the ugly side, and *big*—a major change in the standard of selection, which had always been focused on the extraordinary looking small stones. An example of the latter, in addition to her original balancing work, is Chie's sometimes extreme stones with circles on them, such as the upper stone of AXIAL STONES 15 with its otherworldly eye. It became clear to me that I would soon start working with larger stones, because increasingly that's what I was bringing home. Perhaps with this in mind I picked up the "ugly" stone around midnight, thinking that this stone was far too strange not to be somehow important.

It resisted everything I did with it. It seemed to reject every stone I tried to put under it. Its awkwardness resided in the fact that it was very difficult to handle and would not stand up on its own in any position. I struggled with it. It resisted. I got very frustrated. I persisted. But the more I pushed on, the more absurd it all seemed. Why torture myself in this way, to prove *what* to *whom*? I had no specific agenda; there was no overarching "art" purpose (about which, more further below); and it seemed to come down to a struggle between this stone and me, sad to say. Wrestling with the angel? Hardly; I was in no mood to aggrandize or romanticize the process, which was rather on the side of the raw than the cooked. If there was anything strange to be wrestling with, it would be far more chthonic, and indeed at times it seemed very dark. And perhaps it was at this point that I began *personalizing* the stones, maybe to relieve the tension, at least at first. Yet it quickly became a function of competing, like a child's game, a desire to overcome, and then to out-strategize the opponent. The stone. The case of the self-appointed broncobuster vs. the wily, evasive, elusive adversary—the willful *stone*.

And so I began talking to this stone, coaxing it, even taunting it, eventually threatening it. What a mirror it became! And hard on my conscience later when I saw this side of myself coming out with no justification but the pure desire to win—over a stone! I told the stone: "If this continues like this [it was now past 4 AM] I'll throw you back down the hill; you'll go back to being an ordinary stone."

Perhaps elitism comes easy around stones and is of little apparent consequence, but still it was troubling to have reached this point of confrontation, and without much reflection on the implications. One could see, for instance, a substratum of attitudes emerging into view. Nevertheless as dawn approached matters got even worse, and I

moved toward a mode of ultimatums: I'm going outside to get one more stone from the box of accumulated special stones (I had tried all the smaller ones in my studio), and if this doesn't work, it's the end; it's down the hill for you. I went outside, reached into the dark box, oblivious of possible snakes and spiders, and immediately touched a stone with a very smooth, even sensuous, concave surface. Without hesitation I pulled it out and took it into the studio. And I thought: If this one doesn't work, that stone is hopeless.

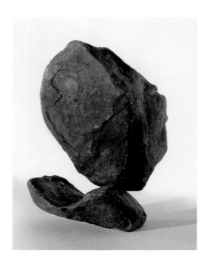

I put the new stone down beside the recalcitrant larger stone; its inner curve was also *visually* striking. I lifted the larger stone up on top; it struck me how much this was like helping a little dog into mating position. This caused the smaller stone to rock back onto one end and the rest of it to lift up suspended in air. Within moments the only flat area of the larger stone met the only flat area of the smaller one, and leaned down into it, causing it to rotate on an unseen axis. Soon it settled a bit, and I felt the upper stone become weightless—a still point—an emptiness, where the upper stone seemed to be going home.

There was more work to be done before it all settled fully into place, but it had reached the turning point, and I now knew that the "union" was near. Moreover I was beyond the backbreaking struggle of the hours before. The event of balancing had begun, and something strange was being born.

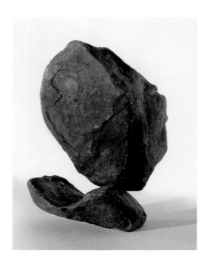
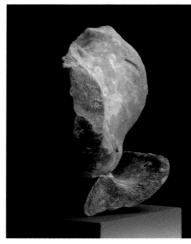

When it reached its new form I knew there was an art that I would practice, an art quite beyond me. Looking now at this self-perfected, processually *found* creature, I knew that the possibilities of "form," in an altogether special sense, lay far beyond formulation, beyond design, beyond procedure, beyond mastery. One would always be a neophyte in this territory. In short: Who could think up such a thing? Certainly not I. And it seemed not entirely *human*.

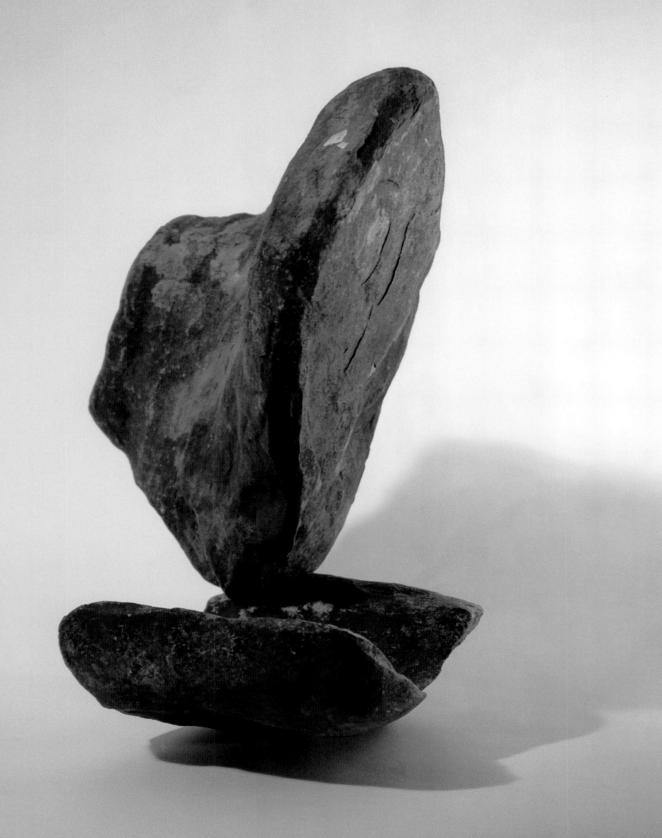

I fall with my stones

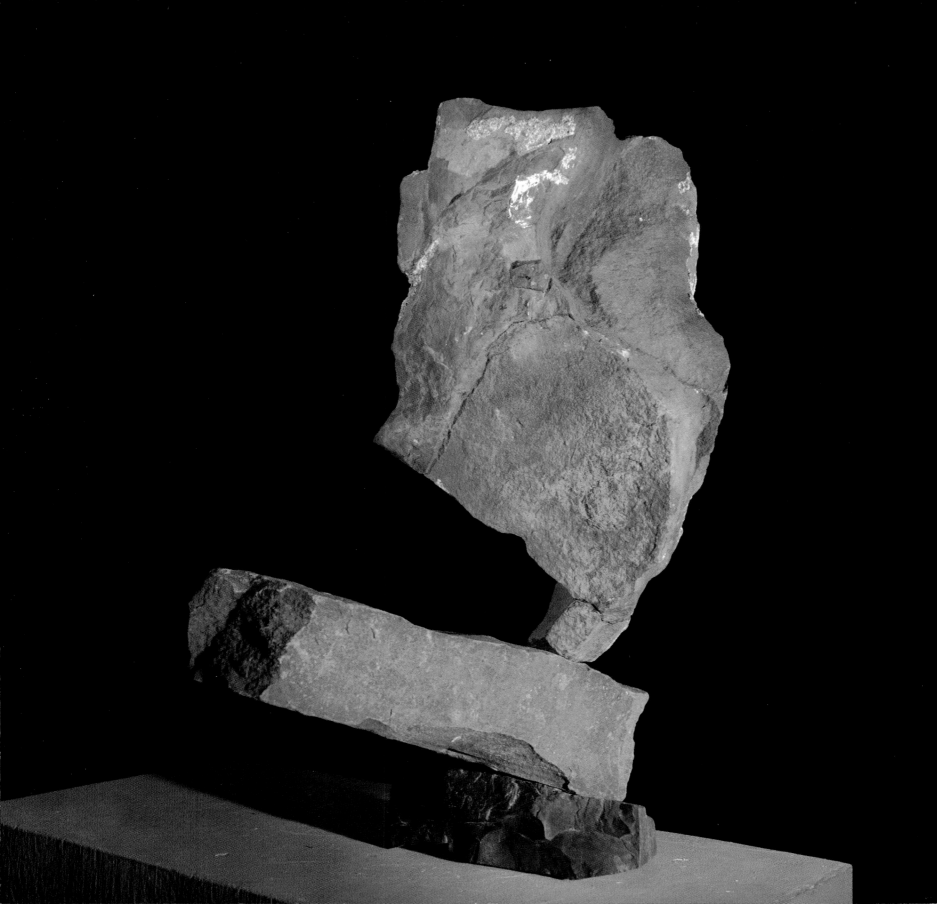

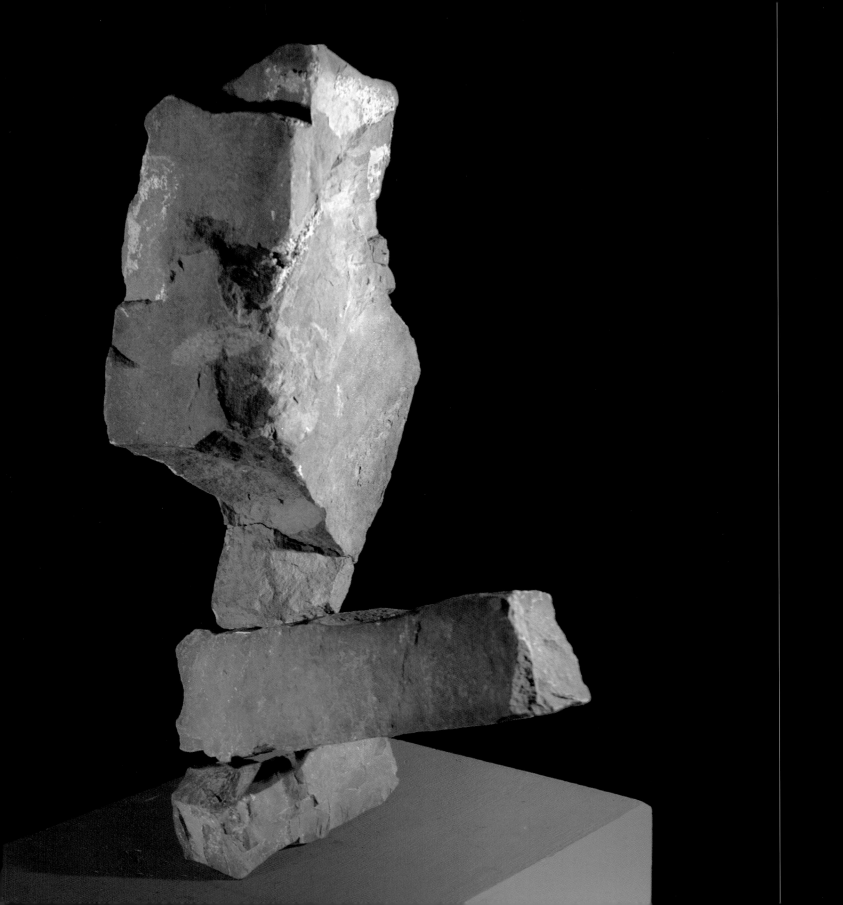

there is no axial mastery

The standard of rightness is the optimal relation.

What is optimal changes according to the forces active at any given moment—powers of the field.

The field is at least as alive as the entities within it.

The standard of aliveness is the precarious.

The standard of completion is

BEAUTY = PRECARIOUS x OPTIMAL

earth releases itself a head apart

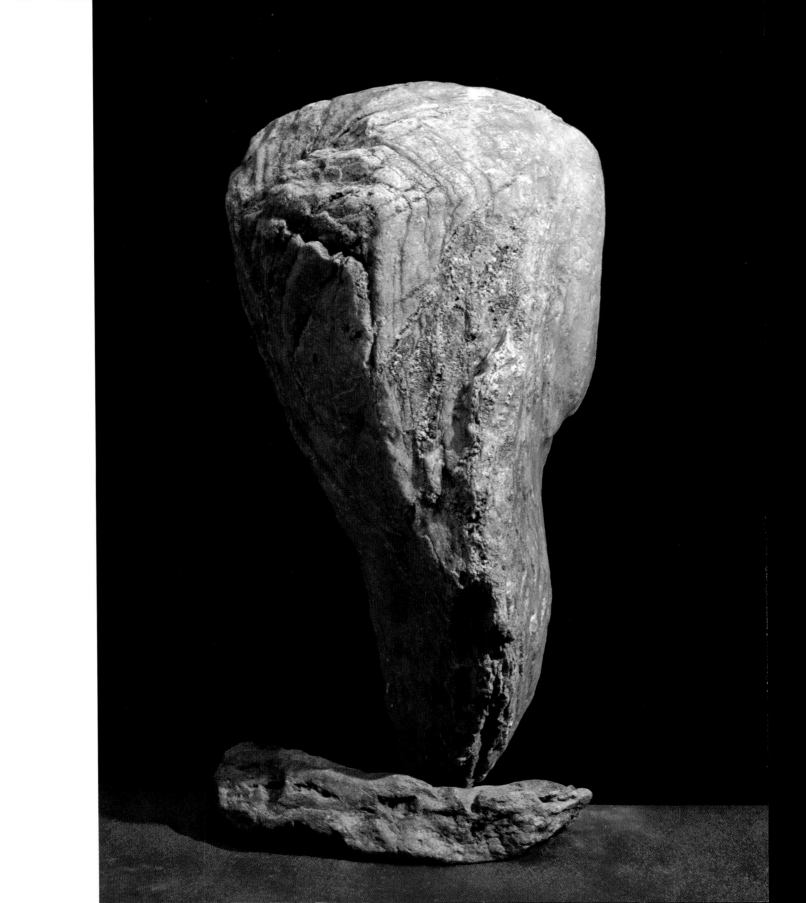

site inflection

Stones come from a specific place. They carry the charge of the place, as well as specific geological characteristics. Sometimes when I first touch a stone it's as though I'm activating a memory of the Earth. I'm turning the stone over and looking into its future, as it sheds its commitment to a given site. The way it moves begins to map its release from a still knowable history. In my mind the fact that it lets me see certain characteristics indicates its willingness to travel, a specific communication that transfers the energetics of one site to another. Something like a bee's transportation of pollen. Sometimes I'm especially careful about the rightness of moving a stone, of taking it away from its native spot. It will become nomadic. A certain evolved sensitivity to stone translates as responsibility for its further existence. And if the stone is powerful, it will affect the place it's transported to.

One day in 1999 Susan, Chie, and I went looking for stones at Bash Bish Falls in the southwest corner of Massachusetts, the State Park located inside Mount Washington State Forest, bordering on New York. As mentioned, many of the axial stones came from this site, in particular the headwaters above the falls, a small, calm body of water that surprisingly and suddenly turns into the dramatic twin falls that straddle a boulder and drop 80 feet straight down. The shore of the lake offers the great richness and variety of stones common to areas with strong moving water.

Late in the day, as I grew bolder in considering stones that would be difficult for me to carry, I spotted an outcropping at the edge of the water. I pointed it out to Susan and Chie, almost as a joke, because it seemed obvious that it was a tip-of-the-iceberg situation—a small protuberance of magnificent ridged stone that concealed an unmovable rock mass beneath. I laughed, immediately thinking of the "Taoist" texture of the famous "Scholar's rocks": "Now that would be an amazing stone to work with." And I approached and put my foot on top with quick pressure of the heel, expecting solid resistance. Surprisingly it budged. And I felt the spontaneous excitement of discovering treasure.

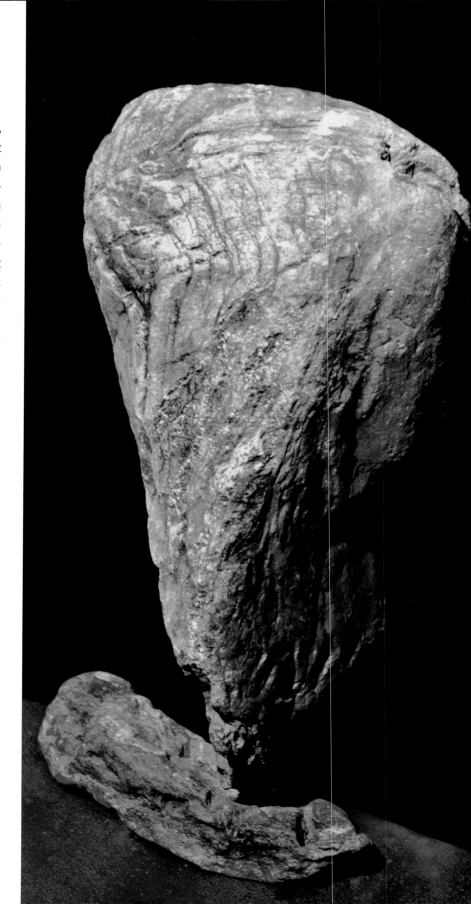

I pried it up and began pushing it bit by bit, until I managed to get it onto the side of a small boulder—it was not a stone I could lift from an odd angle, if at all—so that I could wedge it with a stick and work it up the side, until I found a leveling spot rough enough to imagine engaging the end of the stone. Doubting that it would stand on its small end, I nevertheless had to try, and I hoisted more than lifted it up on the boulder—and it *stood*. I stepped back, startled by its command. Now I could think what it took time to say, and then only among understanding friends: *This is not a stone, this is a god.*

I think I grasped what could be meant by a vexed concept like *otherworldly being*. Here it was—*It took dominion everywhere*. A state of being masquerading as physical fact. A one-entity silently contained Mardi Gras incursion taking us directly to its leader. This was the moment of moments in which to realize the strong pull along the long path of axial stones, which mostly seemed to have no place in the world but this sudden opening into concrete otherness. A moment of *truth,* if by the true we mean a willingness to know something better than identity.

We looked, no *gazed,* longer than was comfortable, all the while holding off the inevitable—that there was no way that we could take this stone away with us, even if we felt right about it (which was gravely in doubt) and even if there was the slightest chance of carrying it all the way up the hill and back to the car. Would it be alright to rip an entity out of its natural habitat—to move, say, one of the cliffs of Dover just across the Channel? I mean there was, more than ever, the question, *by what right...?*

There is no lasting answer, legal issues aside (e.g., who owns the stone?), to either the moral or the ethical question of one's right to take possession of "natural objects," and one's stance depends largely upon the frame, context, and circumstance of the matter at hand. For me, notably on this particular day, it came down to a certain intuition about *how* to resolve the question. For the moment there was no

question of taking it home, since it was too heavy; this was a relief. But *eventually* was another matter. Looking at the stone, it seemed very happy and in its element just where it was. Yet clearly it wouldn't last, for either wind or person would bring it down. I felt sure that kids would throw stones at it, and that in its fall it would break. So we left the site with very ambivalent feelings about abandoning a newly emerged entity, a *former* rock outcropping, *now* an axial stone. The clearest part was that it *belonged;* the question was whether it belonged *where* it was or *as* it was.

On the fifty or so minute drive home it gradually came clear that the matter should resolve itself in the days ahead. It would be impossible to simply forget about it, and of course that was the case. In fact I obsessed about it all week long. And at the end of the week I declared my conclusion to Susan and Chie: We have to go back with a handtruck, and if the stone is still standing, it wants to come home with us and remain upright in the axial state; if not, not. Somehow

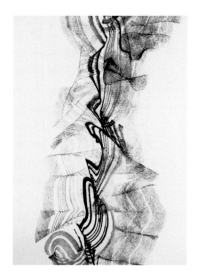

Axial drawing (detail).

ascribing will to the stone seemed to satisfy any moral dilemma; and setting a divinatory standard for a yes/no answer was at the very least practical.

We returned. And lo! Not only was it still standing, but it had truly taken kingly dominion; this was no *ordinary* god. It stood as it had stood up, but with something more. People had put a protective circle of small stones around it. And a crown of pebbles on its "head." It stood ready to extend its domain anywhere we would go. And we felt that we were doing *its* will.

Once home the question became where it would reside, and, since there were no lofty boulders, upon what stone. After several faint-hearted tries, fortunately Chie remembered a special stone that Susan had found a few years before, less than a foot long and with a deeply incised (natural) cross on top. She fetched it, and in a matter of minutes the exalted émigré resumed dominion.

Bash Bish Falls, Massachusetts.

the center of the earth sees through stones

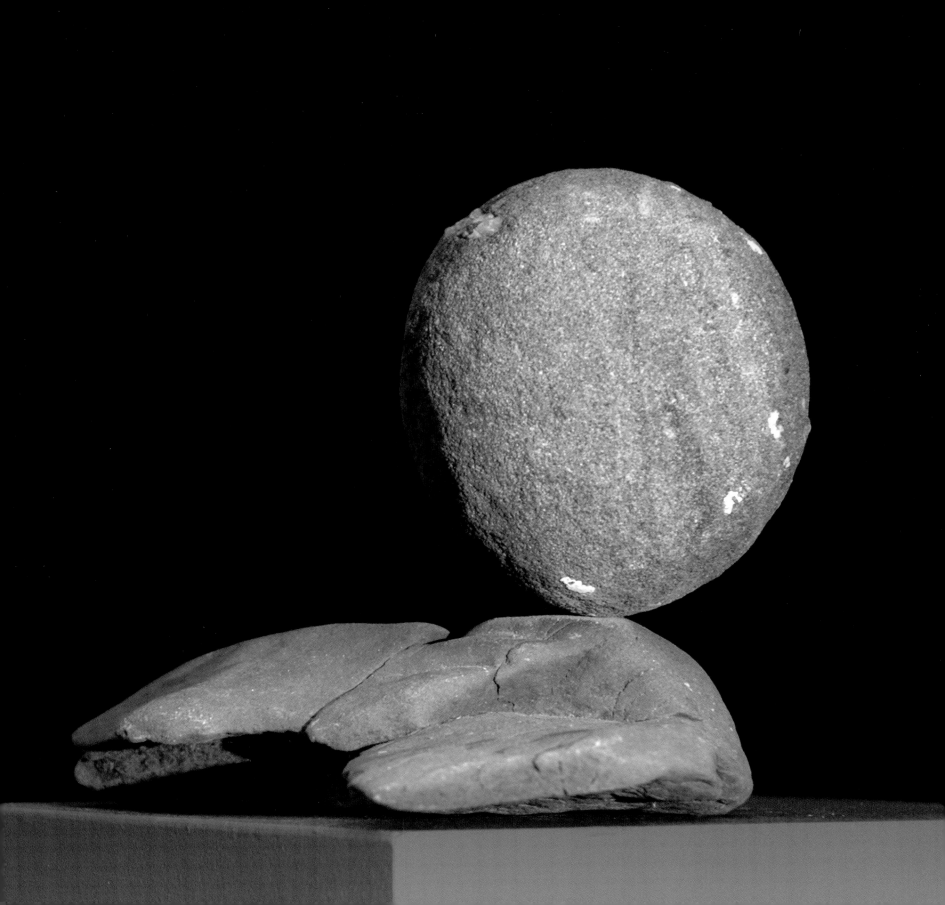

teaching stones

In practical axial work, as I've come slowly to realize, there are two kinds of stones. There are the immediately obvious extraordinary ones, stones beautiful or strange or otherwise powerful in themselves. Sometimes we take them home here in Barrytown just to have them around, and they may never call out to the axial relation with another stone. Soloists, happy on their own.

Then there are the invisible stones, the stones that we see as *stone,* as for instance the most common stones found along the Hudson River. These stones rarely appear as *themselves*. There's a lot of it, forming a kind of rugged surface, a feature of landscape. People rarely pick them up and say, Look at this one! Except in a very particular focus, such as that of a geologist, or, as I'm reporting, of an axial stones practitioner. And that is a special, learned attention, originating in the axial activity itself, a sort of gospel according to river stone risen from the raw shore.

I learned to see these stones inside the axial activity. Suddenly they *appeared* in my hands. I mean, something got me interested in one or two stones of this sort, and once they became axial I really saw them as they are, quietly extraordinary. When fully axial—

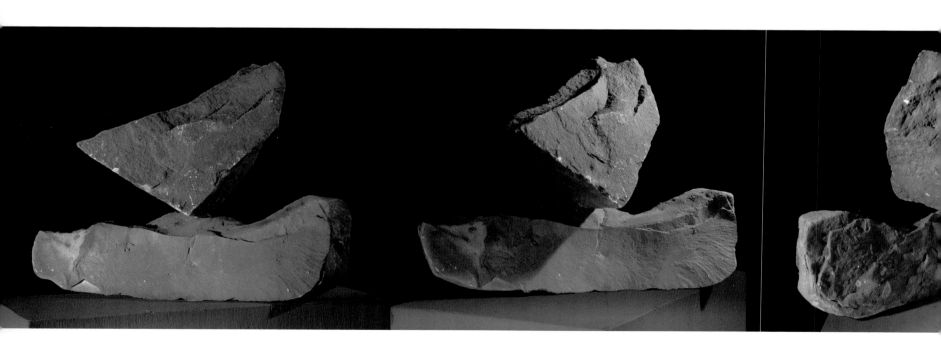

standing up, standing out, set to persist in their further incarnation—they make a new impact. And they teach one to see stones of their kind, to recognize potential, even to value them in their raw state, individually.

There's a curiosity in all this that perhaps can be expressed in a sort of personal myth, which goes something like this: I find ordinary stones that inexplicably appeal to me, take them home, keep them around until they attract another stone or stones, and *I* teach *them* how to engage axially. They come around after a while, so to speak, and learn to enjoy the process and the eventual state of "ecstatic union." Now they are initiated into the axial and soon begin to communicate something unique to themselves, and here, if not before, they begin to teach *me*. They instruct me in their further nature.

Finally, I go out hoping to find more of their kind. It's like looking for sympathetic entities willing to perform their own principle, which in turn is revealed, paradoxically, only in relation to another stone, the other side of its axiality, a stone of similar disposition, caught up in the precarious.

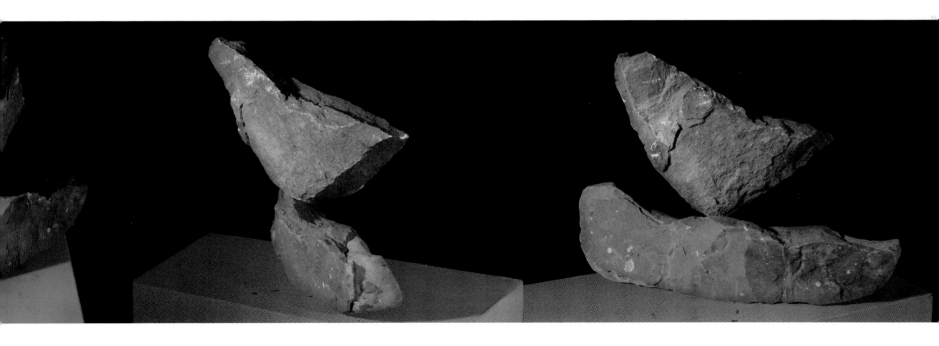

aroused thought caresses its object until it cries out for more

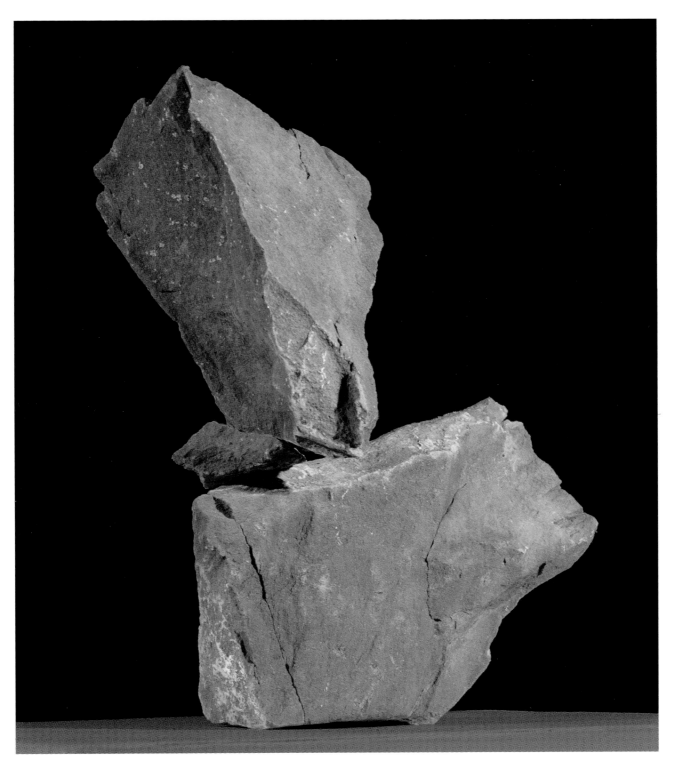

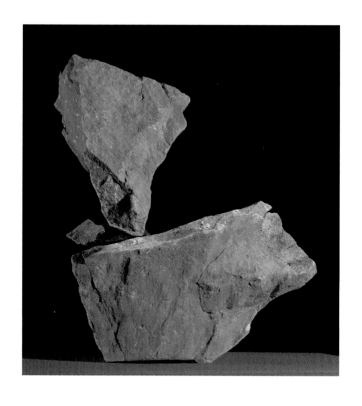

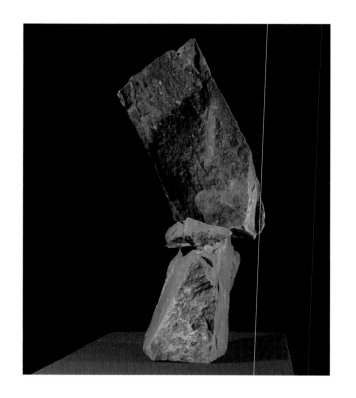

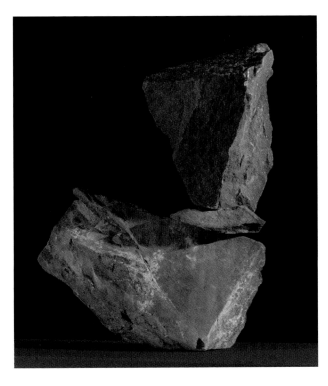

appearance horizon

Working with ordinary-looking stones that are in some sense "invisible," I noticed that they often appear as "stones of a kind"—granite, basalt, porphyry, serpentinite—but they don't come forward as *themselves*. When I walk along the shore of the Hudson, I see a lot of similar stone, seeming mostly unremarkable in itself. But when I go into "axial mode" I see what I don't ordinarily see, and certain stones begin to stand out. Rock lovers may have a related experience all the time; they attract treasures. But I only see stones as really themselves when in this special state of mind. And then the stones select themselves. Later they begin to talk with other stones, and they get me to move them around, test relationships, create opportunities for intimacy. Now they are fully emerging at the appearance horizon, and I know them not only as they are but as they've never been. At the axial moment—the still point—the stones are fully *there*. Perhaps it is I who appear to see.

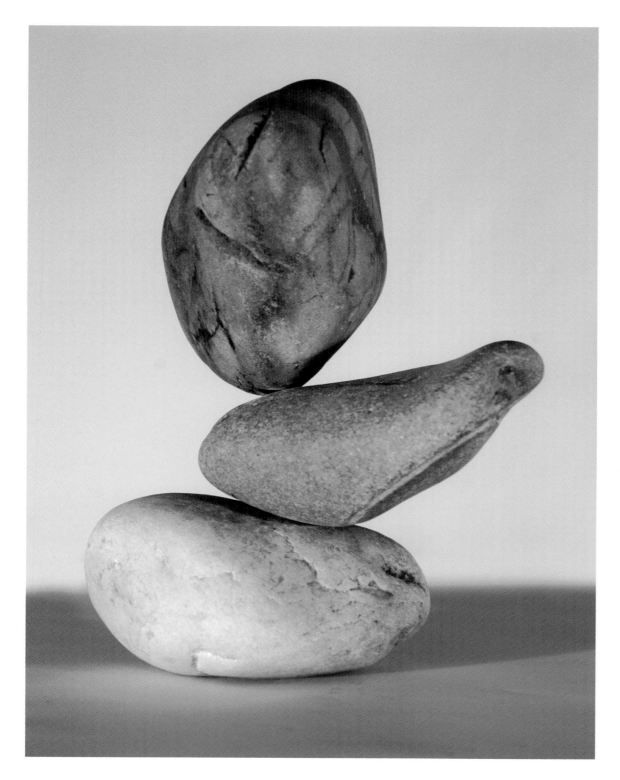

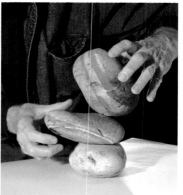

relations

The stones mostly originate along riverbanks, in streams, and around water-falls. In what we call their "natural state"—meaning their *ordinary* condition—they are nondescript, unremarked. Something occurs to displace the inattention that is their condition. One looks directly at them, creating a new axis of attention. Now they are moving in the mind of the observer, turning, and becoming *attractors*.

The stones come into relation.

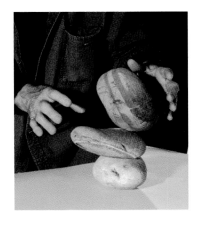 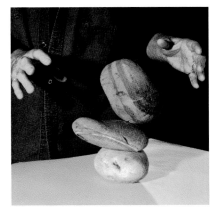

Viewer and stone attract each other, so it seems. In this experience, the stones engage hands, cause the hands to take hold and move around them in manual obedience. Hands bring stones into relation—who can say why or by what tendency of mind? They act out the attraction, perform a sort of mating dance, until the stones discover an axis in common. The relation is momentary, happening only at the point of contact. A new identity comes into being, a *liminal identity* peculiar to these specific stones in hand and their action together, meaning what is actual, yet interactive. They seem to speak out as never before.

Liminal identity. The flip side of anthropomorphizing the stones is their reflection in one's own reflection. Who are we when awake to our interdependence? What excites about not being who we thought we were? Eros, the daemon of states of between, urges us out of isolation and into the action of impermanent connection.

Standing up, or standing out at the point of contact. Getting out.

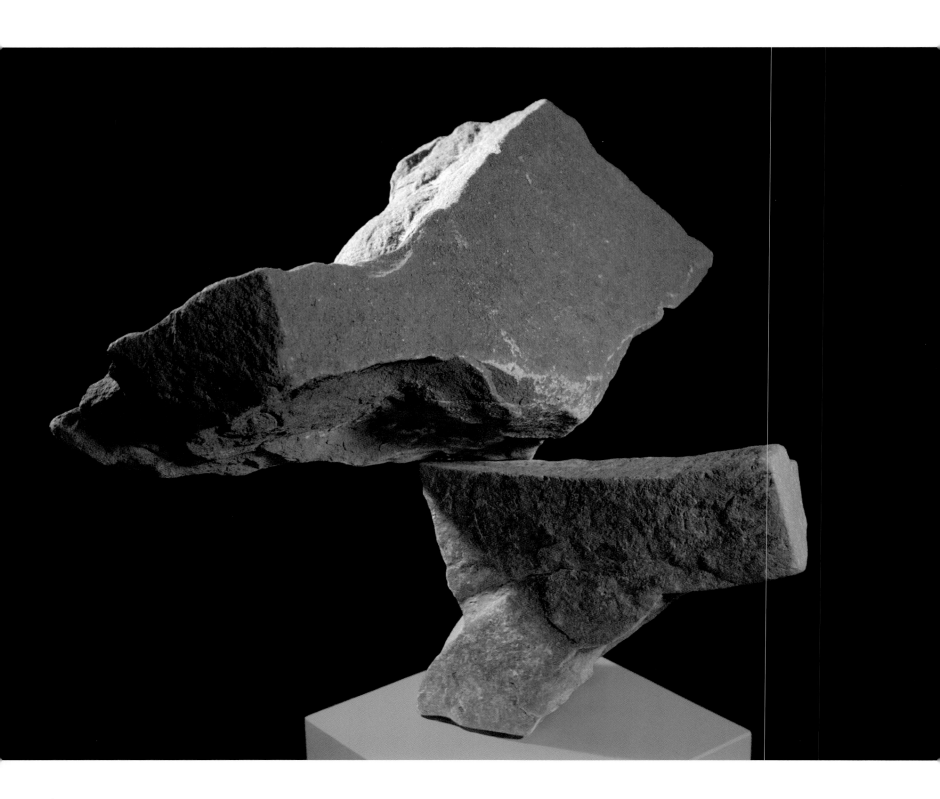

to wake one stone wears another

 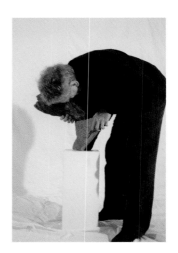

elbow to elbow

The large elbow stone, nearly the span of my open arms, heavy and hard to lift, came home with me in 1998 from the Hudson River bank at Tivoli without my knowing why. And when I moved it around I thought, this one is useless, I can do nothing with it. Abandon it? Yet maybe it's too *strange* to abandon. Then I remembered a smaller elbow stone—homologous, that is, equal in awkwardness, unsightliness, uselessness, impossibility in handling—which had been around for a couple of years. A true marriage in my mind: they needed each other, they were nothing without each other. So I brought them together. And stared at them. Now what? Looking at them side by side I could see nothing to do. Neither would stand alone. I had no ideas. Yet the attraction between them was evident.

I stood the small stone up and held it in position with my knees while I hoisted the larger stone and attempted to place it where it would stay, if only for a moment, to give my back relief. This went on for a while, exhaustingly, with scarcely an idea or an inspiration arising along the way. Two angularly curved stones, so?

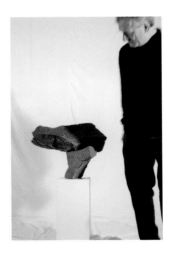

I have no idea how it happened. Whatever it was it gave evidence of the genius of stone, more covert than the genie in the bottle, since even the idea of opening the container was absurd. It, genius or genie, apparently has to find its own way out in the intense confusion of the moment, the grapple at the instant of seizure. And it did: it stood, or *they* stood, as one. And suddenly it had—no, *was*—wings, and the stone underneath was happy to stand impossibly while the stone on top took the position of liftoff. And it stayed *on* to remain ongoing and *off,* still rising. No doubt.

I mean to say it went beyond doubt (*my* doubt), and yet to see it is to wonder.

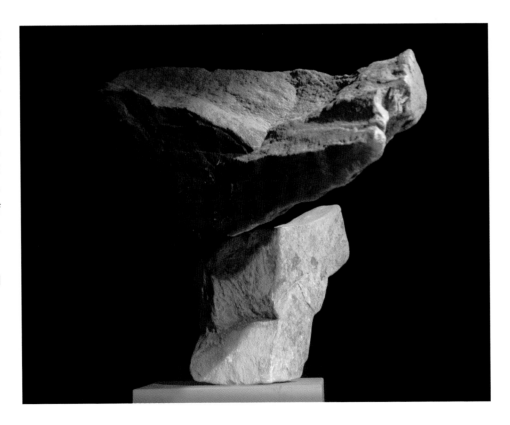

a phantom capacity
summoned into the nearness of awareness

some stones want you to get down on all fours

some stones say *listen up,* follow the tone

some stones are by turns didactic and erotic, on the rise

some stones are not really there—spooks, takes, tracks

speaking in stones between hands

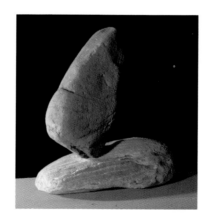

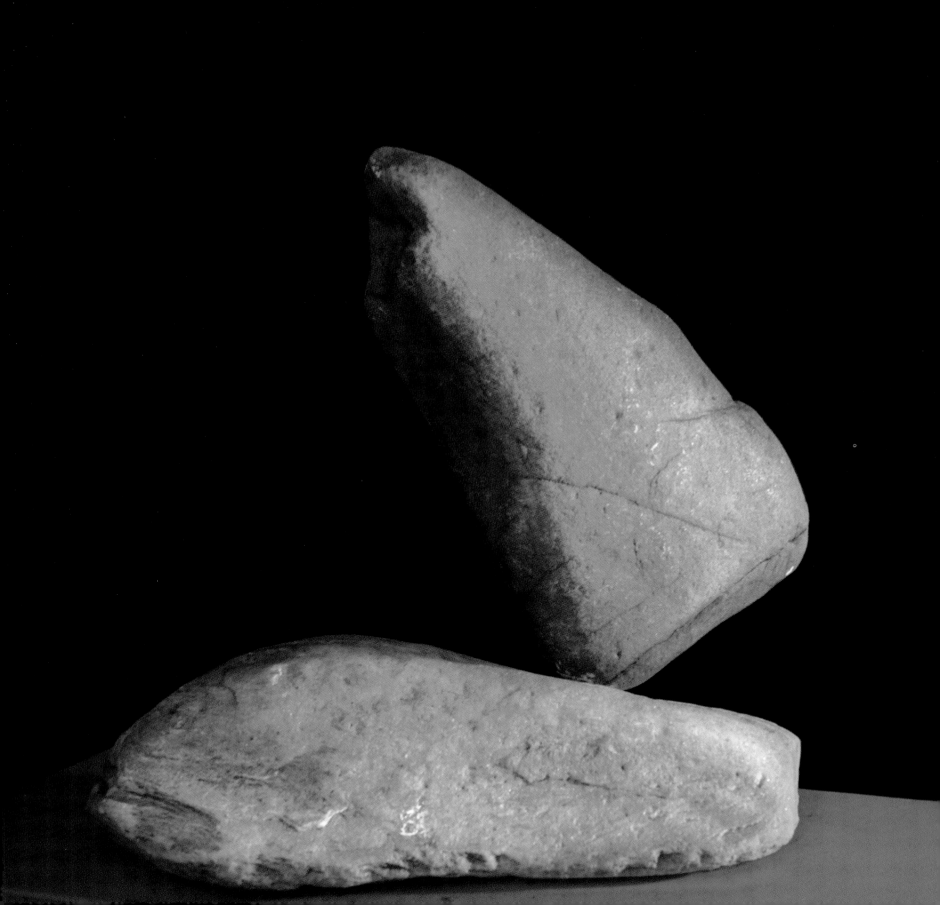

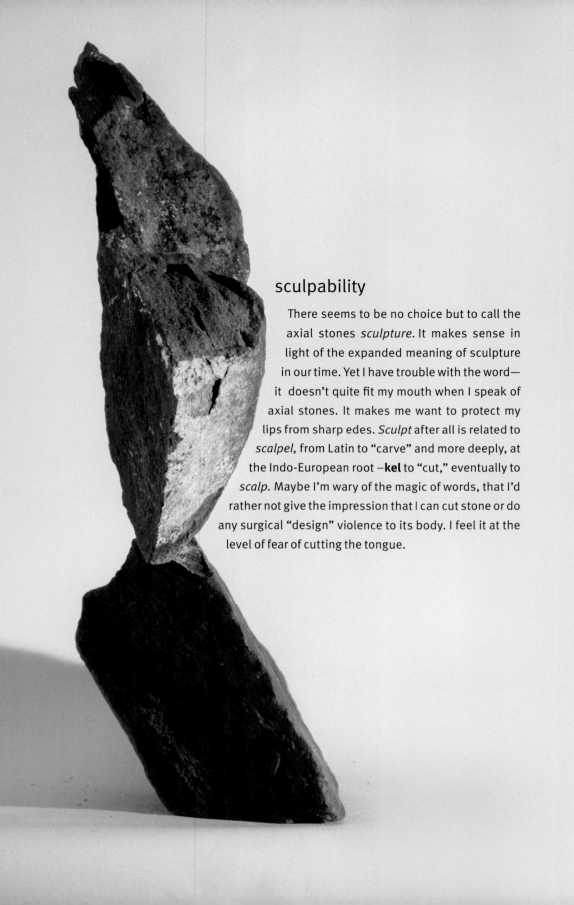

sculpability

There seems to be no choice but to call the axial stones *sculpture*. It makes sense in light of the expanded meaning of sculpture in our time. Yet I have trouble with the word— it doesn't quite fit my mouth when I speak of axial stones. It makes me want to protect my lips from sharp edes. *Sculpt* after all is related to *scalpel,* from Latin to "carve" and more deeply, at the Indo-European root –**kel** to "cut," eventually to *scalp*. Maybe I'm wary of the magic of words, that I'd rather not give the impression that I can cut stone or do any surgical "design" violence to its body. I feel it at the level of fear of cutting the tongue.

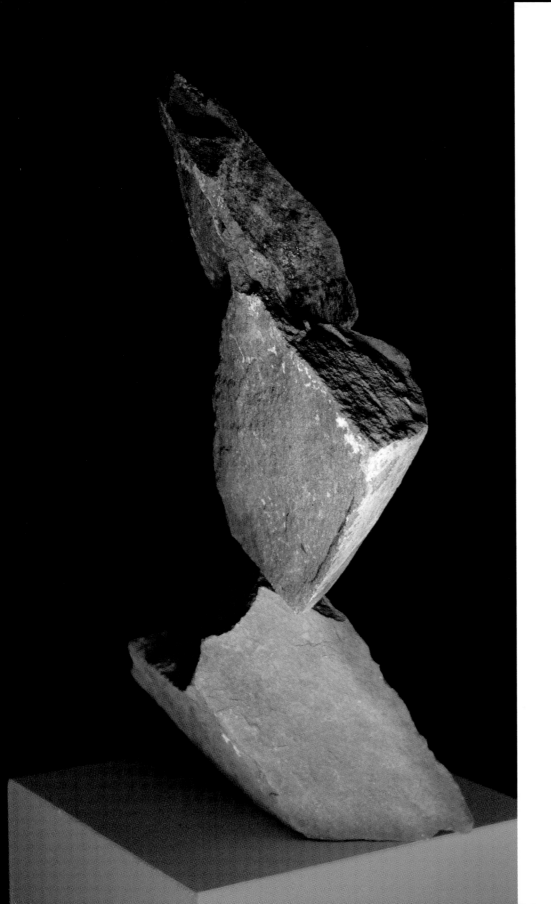

cut

A work of axial stones exists for its moment. Sometimes even a breath can bring it down. It's the moment when it is most free of its gravity that the function of gravity is most in evidence. Its inescapable precarious posture gives rise to a sense of art as what only exists in its time, the experience of being itself.

This moment of being may be the outside of the very time which the art is a *cut through*.

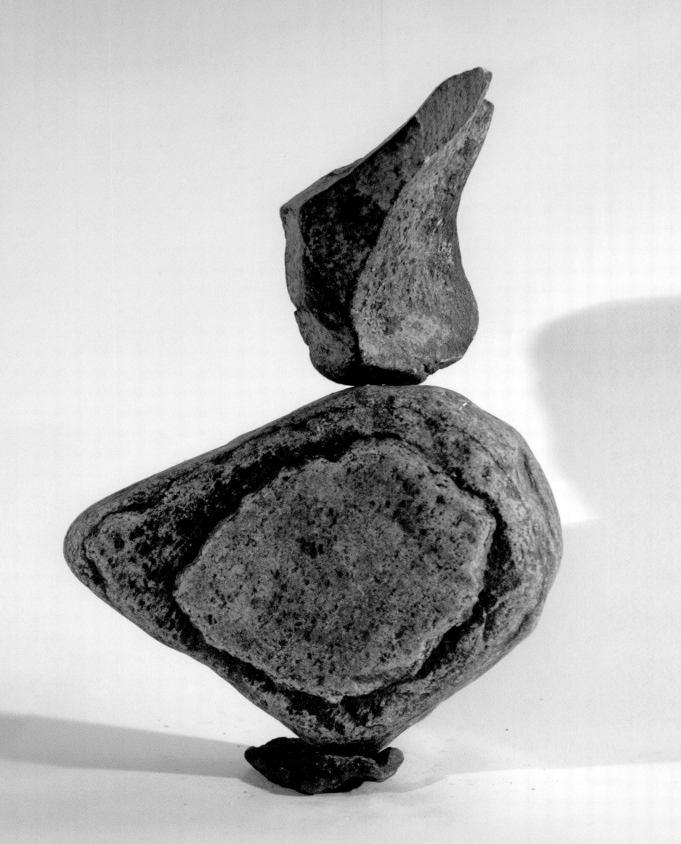

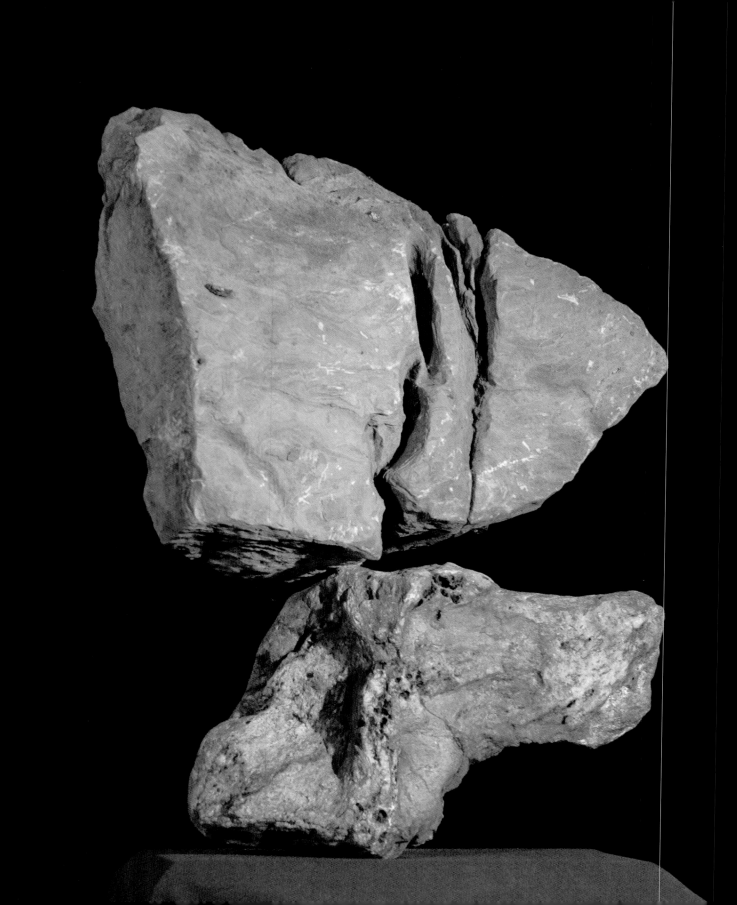

stones stutter to a balance

borrowed time

Some works can be too precarious for their own good. **AXIAL STONES 19** is a now-you-see-it-now-you-don't work. At the time of this writing it *is* not. I mean, outside the book.

I first made the work in front of my house on the covered concrete patio around August 2004. The idea floated into my mind as a completely outrageous possibility—and this is the kind of idea I can't refuse. The principle is: if the idea comes, unless it is life-threatening or otherwise beyond consideration, it must be tried. After an unaccountably short time, under half an hour, it worked, as shown in the picture. That difficult but quick realization confirmed the feeling of inspiration, that the signs of a true impulse (as distinct from a wild idea) were in fact present. Yet inspiration is not realization, and it couldn't happen without help from my cousin, John, who was conveniently nearby. I doubt that this one could be done alone; someone has to hold the understone, which rests on a tiny area of slightly flat surface, and which is hard to keep on that spot. Eventually John learned to hold it almost stably at the odd angle and on the minimal surface that lets it "sit down" through itself. Now I could place the large ungainly upperstone slowly into position. Inexplicably it finds a tiny area of contact that, after a relatively short (but experientially excruciating) time, just barely hangs on, and I can say to him, let it go and see what happens. It stayed, and I was incredulous far beyond what I am used to even with the most difficult stones. And it stayed for several days. There are photos.

Yet when it came time to transport it to another space, I had difficulty. In the Stained Glass Studio it resisted being set up a second time, but again, working with John, it suddenly happened. And doing it again after only a few days emphasized the need for faith in the process and for the strange feeling that comes when it suddenly *falls* into place. The stones exhale—at least, through me. Anyone watching feels the release and the relief.

When I selected this work to be part of the Baumgartner Gallery show in Chelsea in November 2004, I had no idea what I was getting myself into—a special disappointment that would challenge my sense of rightness. John was unfortunately not part of the set-up team, and when the time came—the narrow slot of time of several hours we had to set up the eight

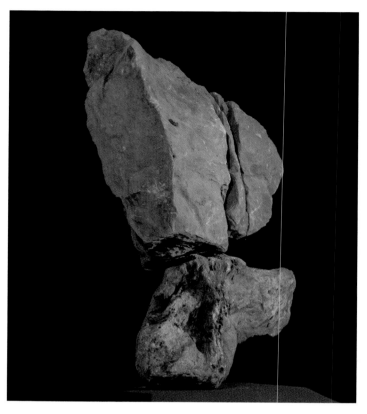

works and find their proper place in a difficult gallery space (with a large unmovable column interrupting the main area)—**AXIAL STONES 19** would be the weak point in the assembly. Several works offered resistance and took painfully long to set up, but this one proved impossible to bring to full realization in that context. In the end, exhausted, I accepted an inadequate realization, a secondary version, that had a certain appeal but left me a little depressed. At the time I decided not to mention it and to let people react on their own. I felt I had lost something, that I had given in, and the feeling never left—for me, the one blemish in the otherwise very happy show. This taught me that I was not free of a strange perfectionism that I thought was the enemy of the axial, but now I could see was part of the principle: each self-true realization is its own perfection. I see no way of explaining this sense of rightness except in each particular case, by example.

When it came time to set this work up for the present book—which I put off till near the very end—I experienced a certain fear. A fear, admittedly, of failure, and of a repeat of the New York experience, which was in part a result of having too little time to set up the show and therefore being exhausted. However, under the pull of this book trying to come into being, I decided to persist: the reality of AXIAL STONE 19 in optimal realization was compelling—I could still feel it, the stones had something to say and, despite all appearances, were still willing to say it, at least one more time.

This time John was available to help, and I had the thought that he was an essential part of this process, as if the stones were attached to him. And this gave the idea that some stones may after all have a certain site specificity—do they love it *here* but not in New York City? Or perhaps a *person* specificity, a sort of family thing, my working with John? At this point I can't prove otherwise. When we went to set up the stones for the photos, this time in the Barrytown octagonal Mandala Room, the magic returned. Yet not without the familiar process of sudden despair, fear, lingering threat of early resignation, certainty of failure, etc. He was able to hold the understone in position, with difficulty. I set the top stone into approximate position and began to work it over its spot. It's heavy, unwieldy—the absurdity of trying something like this hit home for the umpteenth time. The tiny area of possible balance suddenly showed up, felt through the hands, and yet it was so flimsy that I almost rejected it—what's the point? This can't hold! Even if it does it's but a flicker, lasting only moments, maybe long enough to photograph, yet not much more. Why bother? And who cares or would know the difference but me? I was about to give it up when I felt it fall into place. I said to John, "Let it go." He did. The stone stayed.

Or at least it held on there in midair, for the moment.

Fall! What an idea. We say *fall into place* too easily (too *lightly?*) and fail to appreciate the weight of the truth. Here the weight is literal and a matter in the hands. And the "natural metaphor"—the Fall?—my mind has tussled with it since age 14 when I began to realize the perversity of carrying the burden of universal guilt and the way it has of

restraining one's energies and dampening aspiration for its own sake. I walked away from all churches. And yet now as the stone falls from my hands into place out on its ledge over its inevitable abyss, I see that, if there is a Fall, its trace is a certain resignation that lingers there at the edge. My mind recognized a certain inherent—well, is it really?—human defeatism, easily disguised as guilt, mythologized in order to justify or disguise—showing up, for instance, as a certain *this can't be*. And then, suddenly, as if by happy accident, it falls into reality and, against all odds, it is.

Fortunate fall—a strange and vexed notion, which seems willing to migrate beyond its theological limitations. The multidirectional reach of "fortunate fall" is a difficult thought to hold on to. Perhaps it retains within itself a certain *hidden axis*, an obscure place of meaning that freely turns, which is what makes it both attractive and dissembling. If so, its root freedom is all too easily held back by dogma, most terrifyingly *not* actually the dogma of Christian guiltism, but something even more basic and perhaps unexplainable (hence mythologizable) and present in every moment, the immeasurable weight of impossibility, an always already *cannot be,* holing up in the badlands of the body itself. Something that when it does get overridden shows the covert *function* of blind ego, bravado, or whatever it takes (alcohol, drugs, fury) to drive the varmint out.

Whatever it takes—or what makes the Fall fall so that anything is finally *in place,* without extra weight, and the tiny space opens just enough to interrupt the limiting thought, and there is a thin film of faith—that anything is itself possible yet only at its edge and out of the reach of—what? Dare we try to name the fiend? Or maybe just speak here of the *pre-fallen* stones, so that the axis of meaning itself falls free.

Or as Blake said:

There is a Moment in each Day that Satan cannot find.

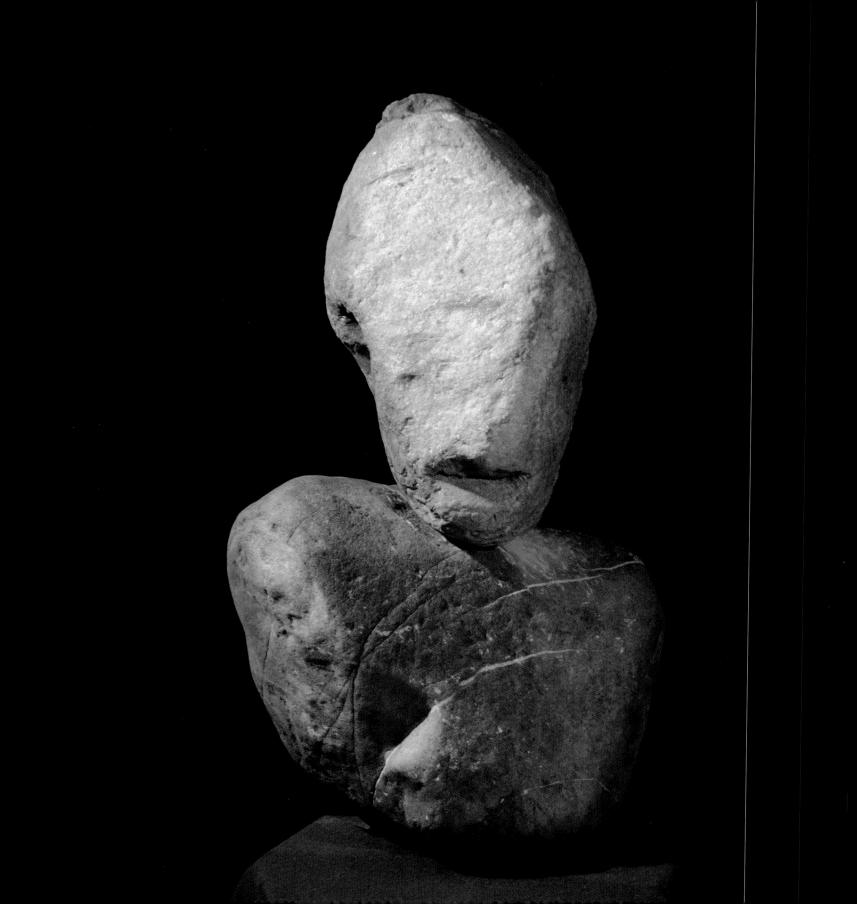

stones lift mind first

standing true

When axial stones are exhibited, viewers often ask me whether a particular balance is the *only* one, the *right* one (and, if so, how do I know?). If the stones fall and I have to put them back together, is it the same? There's no single answer. What is *the same?* Albert Lord in *The Singer of Tales,* his study of Serbian oral epic poetry, reports that a singer claiming to sing the same work in different towns will vary the length and content of the work significantly, depending on audience response; if asked, he says the poem is *the same.* Similarly I'm never sure that I have gotten the stones back to where they were. The point is they—now an *it*—feel and look right in the moment, and *it* seems to like being where it is. It's *the same* in that it's still *right.* It's standing *true.*

When stones fall, it's startling. I can feel anything from upset to anger to amusement. Many times, if the stones don't get broken in the fall, the new arrangement is more exciting—it goes *further.* And I feel grateful, as if the fall expressed the stones' wish to move beyond where they were—a sort of *felix culpa,* fortunate fall. This experience helps remind me that the happy result of the spontaneous event of creating/discovering/enabling axial stones is not itself set in stone—it's *stones set on edge.* The mind changes—*whose* mind is not clear.

Furthermore the stones are minutely moving by themselves all the time, as the Earth moves. That's why axial stones can remain where they are for months, years, and suddenly, unprovoked, they fall.

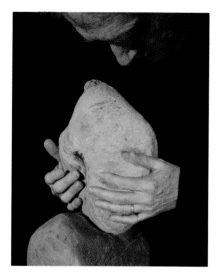 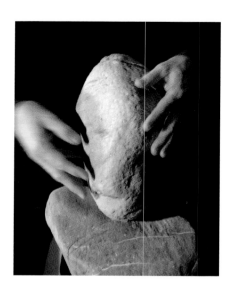

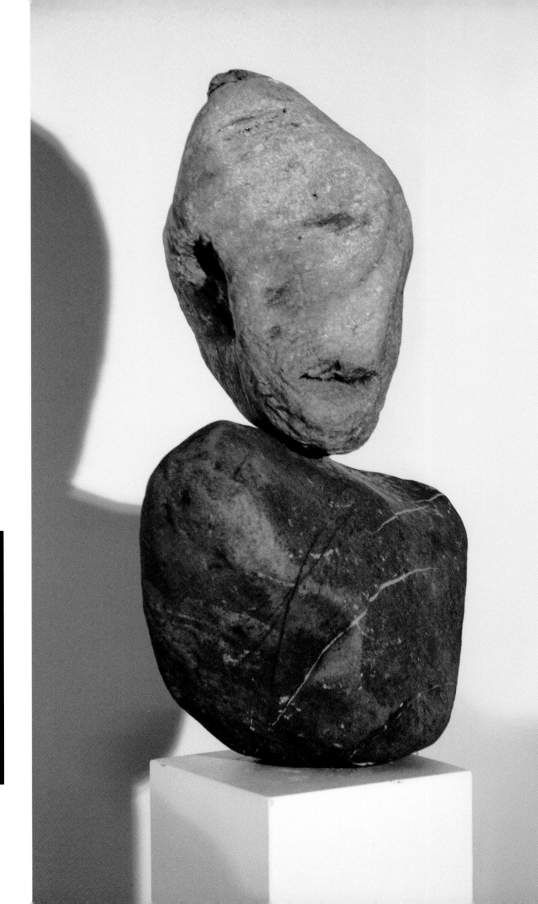

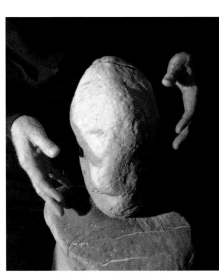

stones on edge draw attention equal to the space around

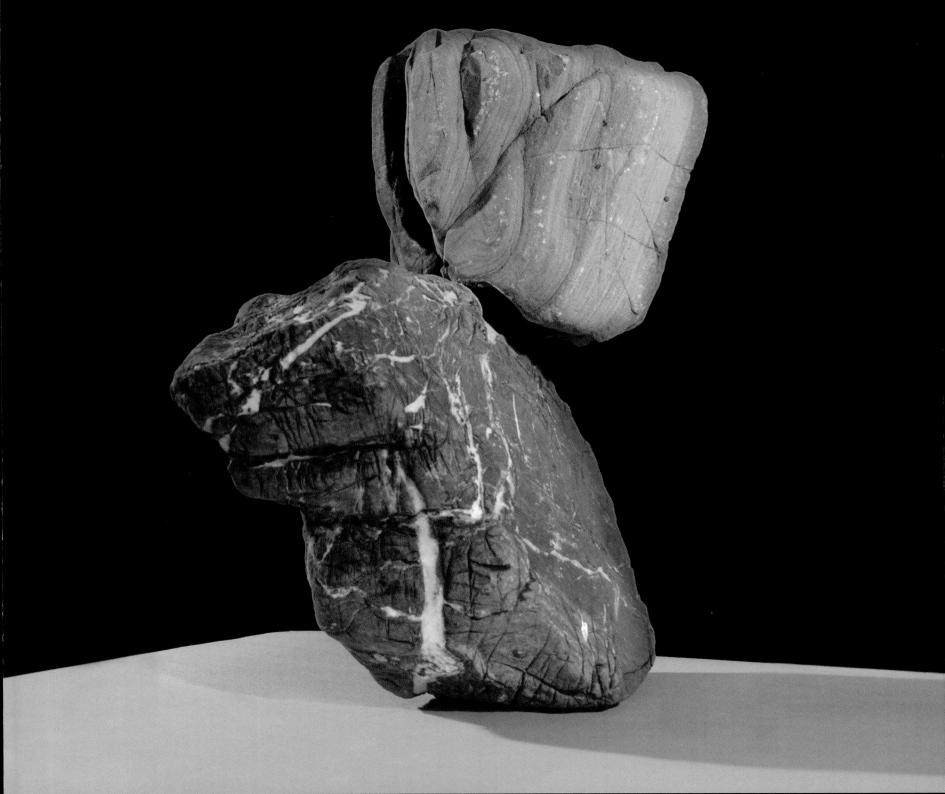

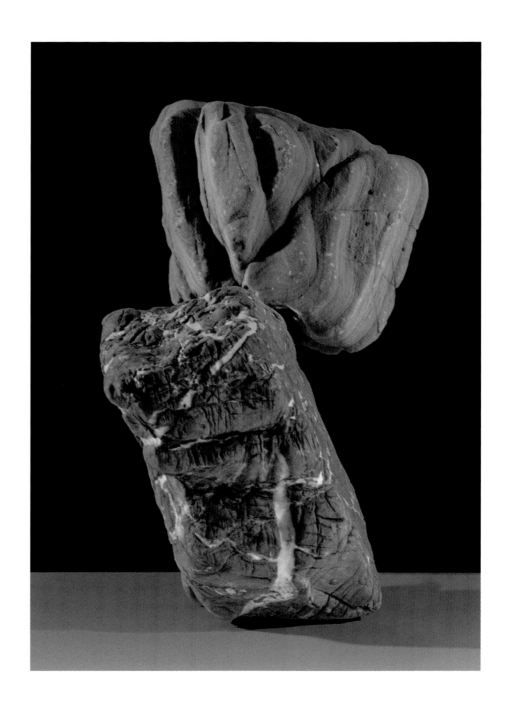

strange retractor

Stones confuse. They attract chaos. They literalize contradiction with the fearsome authority of bone crackers. After all, they belong to the underworld. To them it is not self-evident that giving up their dark story *lightens*.

They rise only to gnarled tones of Persephone.

In a previous incarnation—but I should say, in*stant*iation—these two stones of AXIAL STONES 33 were reversed. For maybe a year the hulking huge and dangerously heavy bottom stone improbably rode on top, as if with invisible elephantine wings. The now upper stone—a simulacrum of an imported miniature Southwest canyon—bore the insult of massive imposition quite gracefully, but then showed signs of structural fatigue—cracking along fault lines, some apparent crumbling. It was a grand sight, and a sad one too. So, reluctantly, I reversed them (a rare, maybe even a unique event, at least on this scale). I feared that I was violating a given configuration, and out of the base motivation to merely preserve the work. Had the *precarious* lost its value? Translation: had I lost my nerve? Was I running out on the commitment to face impermanence in my art?

I ran the risk. And then the real magic happened.

First, this mighty wall of granite can't stand on its own one foot. Lightweight curvaceous inwardly folding would-be canyon miniature to the rescue. Push it out over the edge and let it hang there, cocked, poised, gorgeous, terrifying.

It stands for giving up knowing what it is.

AXIAL STONES 30, 33, and 16 in the Stained Glass Studio in Barrytown

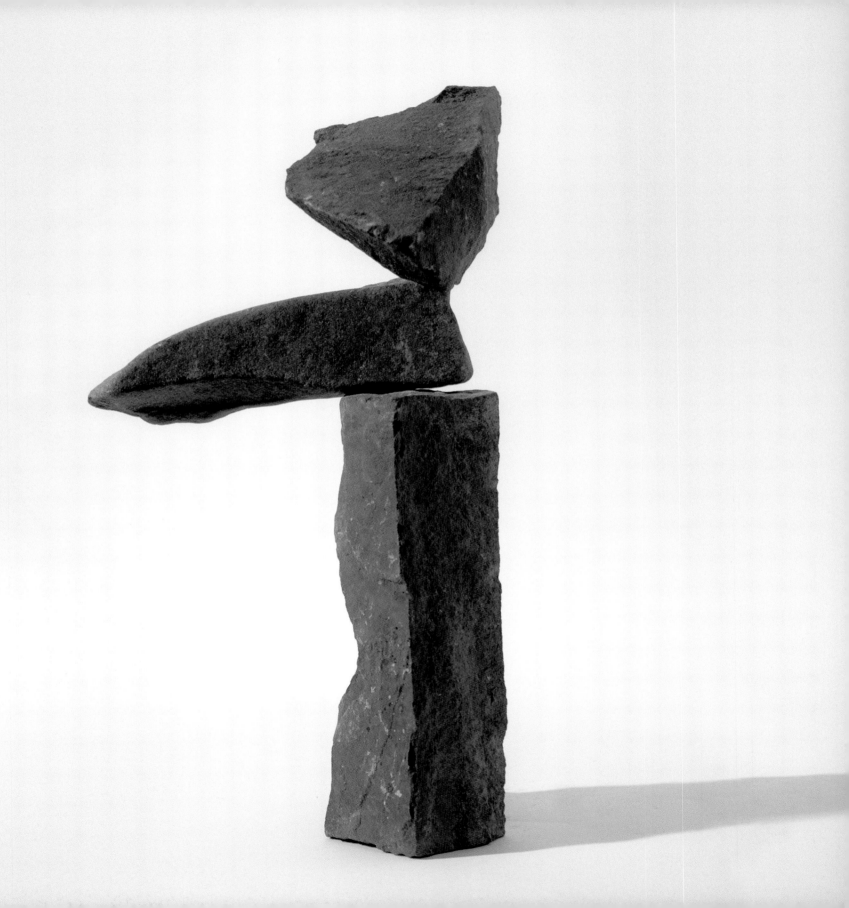

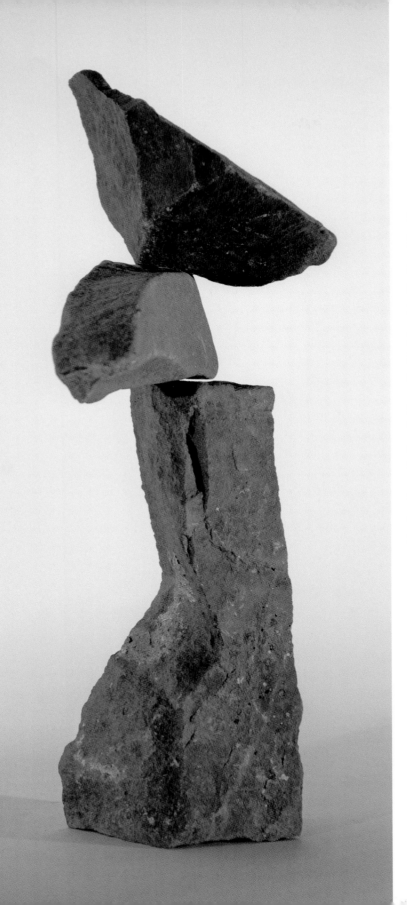

a thing lets go in the mind returning to itself

In the wild, in nature, certain objects serve as nodes to get oriented by. Then the things noticed are at the threshold of themselves. Limens, gates, the point between identities.

I may hold it in my hand and still not know it for itself. If I refrain from calling it what it has not yet declared in me, the door swings open. Or I become its door. A way away. Now it is possible.

It tells me how to attend, the mode of its attention of which I am capable. The object and I go to school in the zone of between. The hidden wholeness of the marginal calls us where we may have thought we were only dreaming. We were not only dreaming, and it was not only calling.

Virtual symbols—they only hand us the other half of themselves when the *use* momentarily appears. Being *mind-degradable* they return to their own potentiality when out of use.

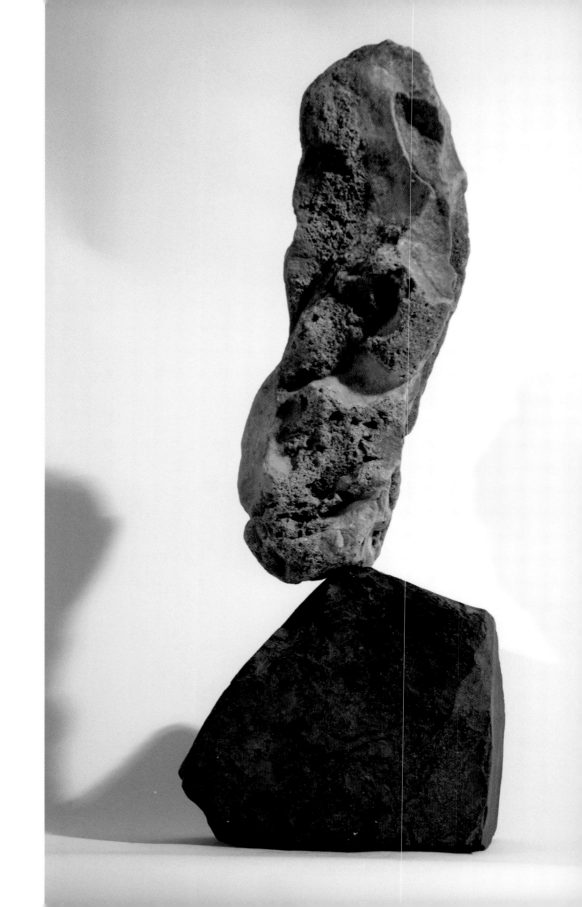

things done for themselves are the only things done for all

ambiguous matter

Some stones don't look like themselves.

Shift the view and someone new shows up.

Viewer renews.

Sensing the *same* affirms the liaison.

Yet what shows as the same may be the subtle mask shielding us from the strange—even "monstrous"—difference facing us. (*Monstrance* in the jargon of the Roman Church indicates the "showing" as portent and receptacle that holds the host.) What shields may covertly reveal, or it *lies* in waiting.

In the axial state of open perception, things we ordinarily can't stand may reveal an attractive, even salubrious, face. Freed from predilection, unique being shows itself *for* itself. Art for *being's* sake.

Stones are not one kind of thing. As with people, whenever you think you know something definite, you soon see it has changed, perhaps within the space of a thought. The axial process speeds up the discovery of continuous difference. Instant by instant the change can be dramatic; the curtain never stops going up.

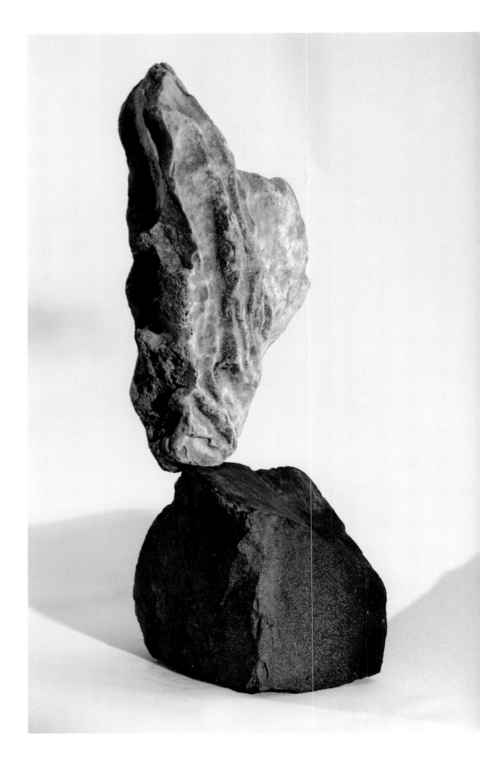

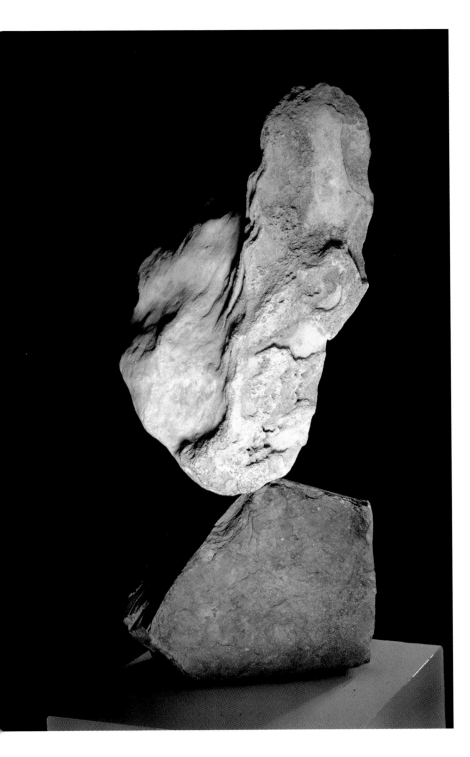

In the case of **AXIAL STONES 23** the name is already at variance with its object, a sort of misnomer. The upper piece may be something organic, a petrifaction; it looks like coral. The lower is coal, which is fossilized plants, amorphous carbon, with both organic and inorganic compounds. It weighs little and looks like graphite. Put it under enough pressure at high enough temperatures, and it can become diamond, the hardest naturally occurring material on Earth. And then it would be a *stone*.

Coal and coral, pretenders to stone. The coral bears the impress of flowing water and has the feel of hardened movement, like human bone viewed up close. We don't think of bone as resonantly and flowingly patterned, just as allopathic medicine till fairly recently often had a limiting view of bone's regenerative capability and range of flexibility—the fault of studying mainly corpses. On the scale of human life it's just a slow flow, able to remake itself in surprising ways. Maybe coral is ocean bone. And stone is earth bone, scaled to millennia.

I wonder if a blind healer palpating this coral stone of unknown origin would register the grooves and ridges of remote Southwest canyons, portents of shifting health in the body of the nation.

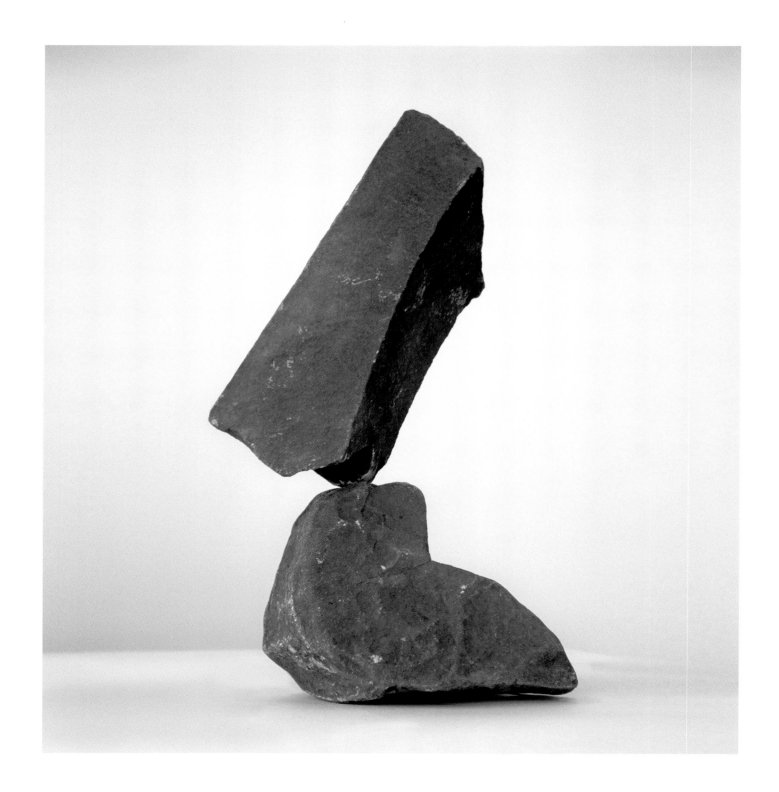

a total lift tips abreast to breathe itself out over

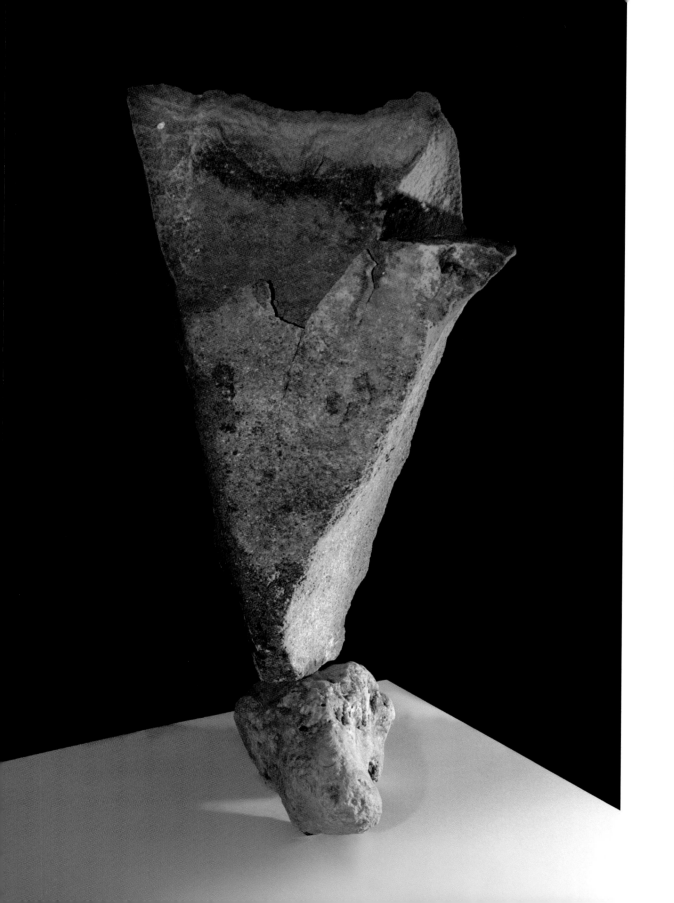
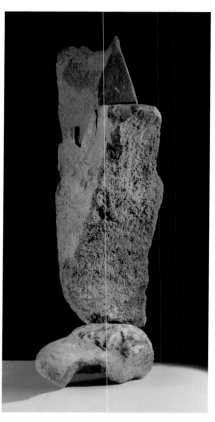

so called

There are stones you wouldn't want to meet in a dark alley.

There's always the danger of becoming indistinguishable from the thing that goes bump in the night. The dark is where we configure wildly. Juliet's "wherefore art thou," while hardly asking of whereabouts, is playing on the dangerous darkness of identity or identity in the dark, where *location* matters: when you meet someone in the dark you utter some version of "who goes there?" or "what's your handle?" (as radio hams put to voices in shortwave obscurity). So *wherein* one is *who* one is has a lot to do with names, which apparently sheds crucial light on the matter. In what sense are you a named being, a being of name, my *socius*, designated companion, ally even in the alley....

Namelessness—the unnamable, as Beckett named it—is a state of darkness as *identity chaos,* and one that is implicit in the "state of nature." Nakedness in society might indicate a liminal personality. Running around without a name can land you in the loony bin. Wilderness is not welcome in polite company. Wild women, wild dogs, wild ways—that's where we draw the line. Stones, they're OK wild.

No one expects a stone to hold a name. To get familiar with things that far from nomenclature crosses a line, unless it's science, art, or religion. Otherwise it could be fetish, or worse. We're talkin' black magic, devil worship, gettin' your mojo workin'. There's a line. It has to do with who you *hang* with.

Things on the other side of the line have to be handled. The stone can be made to look like something, sculpted, scalpeled. Then name is implied. Enfolded stone. Held in place.

Maybe.

AXIAL STONES 31 and **27** in the
Stained Glass Studio

When I set up this large critter of a stone, I had to throw my arms around it. Face to face that way I felt I had hold of someone or something from somewhere else. Still, I didn't exactly get familiar. The edge it stood up on was also the ledge between us, a threshold of difference that excites connection without inviting intrusion. The bounding line bears truly right there in the up-close half-light.

It's not that there isn't a call to cross. The art is according to the call on hold.

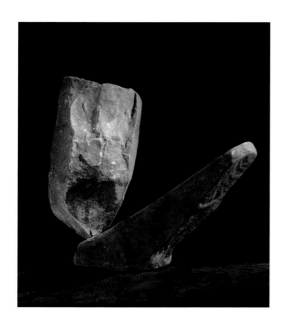

who's holding who

The loose grammar in this titular question holds an insight.

The double subject and lack of true object in the question complicates a simple answer. The space of answering stays open. Translation: *who's holding who's holding?* A double subject can mean twin subjectivity, which is a state of intimacy I believe art longs for.

In many of the axial stones, like those here (or a few pages before, **AXIAL STONES 33**, or after, **AXIAL STONES 22**), the lower stone won't stand up alone but needs the upper stone, which it holds up, to hold it up.

Interdependence as twins akimbo.

<p align="center">beauty = precarious x optimal</p>

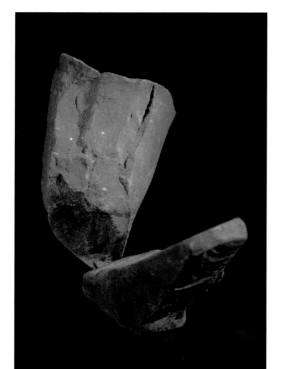

So there's a species of axial stones in which the reflexivity between upper and lower stones happens inside an ambiguity: which stone is defying gravity and which is enjoying levity? It seems they're reflexive in the equality of shared function, and the dualistic question (which is which) is hardly appropriate. No doubt this compelling state of precarious balance in relationship has relevance to gender (at least at the level of what might be called meta-modeling relational possibility). Whether it's at the level of *girls and boys, play nice!; who's on top?;* or *oscillatory gender function,* the fact of there being something fundamentally undecidable encourages openness in experiencing gender (however it's formulated). I'm conscious of a certain oscillation in the master/being mastered stance in interacting with the stones, which holds open *my* axis in the "axial performance." It's like being in training for ever-new disinterested gender thinking.

<p align="center">beauty = optimal x precarious</p>

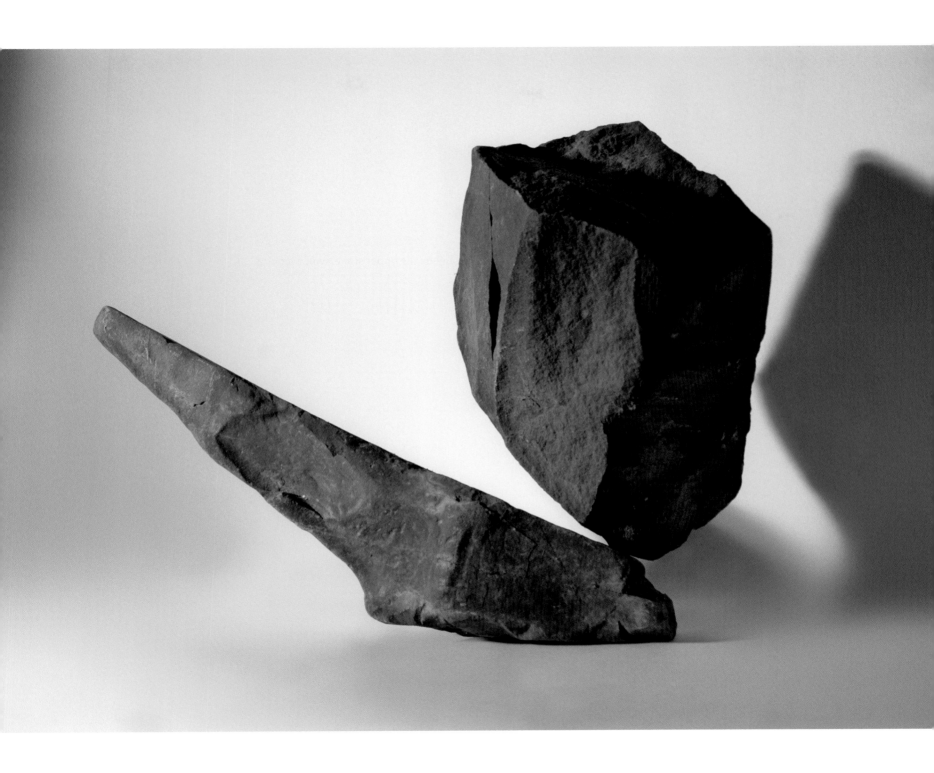

leaping between two worlds

bearing neither

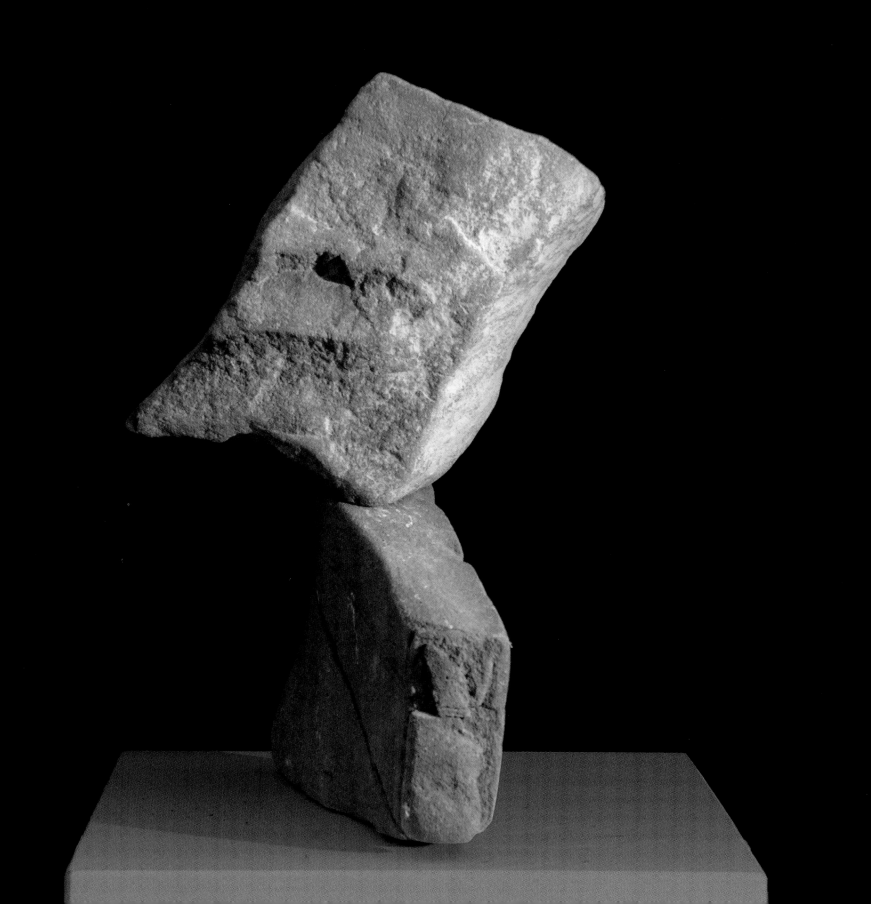

appearing edgy

Axial stones often look "impossible," which is in part what makes them exciting to look at. I admit that I "stop improving" the fit between stones at the point of greatest excitement in beholding. (I say "beholding" to neutralize the issue of *visual* vs. other senses.) An odd aspect of this is how much it's a matter of *appearance* and not "actual fact," to state the issue simplistically for a narrow focus. Is it a *visual excitation* or a *physical excitation* or perhaps both—or even *neither?*

Simplicities first: Some axial stones look "impossible" yet in point of fact are not necessarily among the most precarious. The fact that the center of gravity is hidden and unimaginable in the abstract makes possible a sort of ambiguity in appearance, or even a *sleight of appearance*. In the example of **AXIAL STONES** 4 (the two "elbow stones") and **8**, for instance, while these events were very difficult to discover in the first place and may even, as in the case of 4, be difficult to repeat, once they're established they are relatively stable and can be lightly touched without falling.

Other stones may look rather well seated and fairly secure, yet are really on the verge of falling, and it takes next to nothing to bring them down. Even I, knowing the stones well, can barely touch certain stones (such as **AXIAL STONES 6** or **18**).

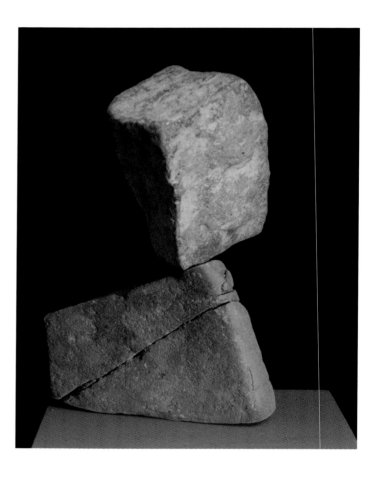

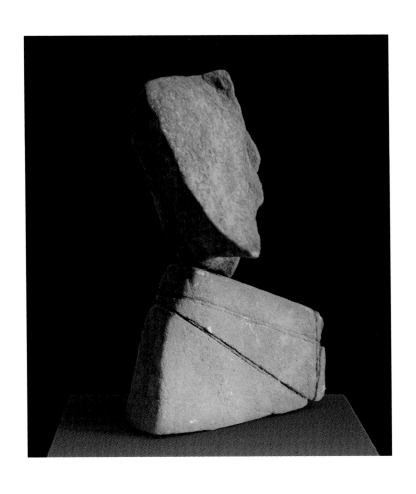

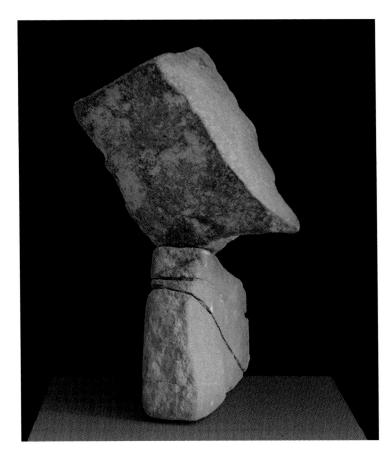

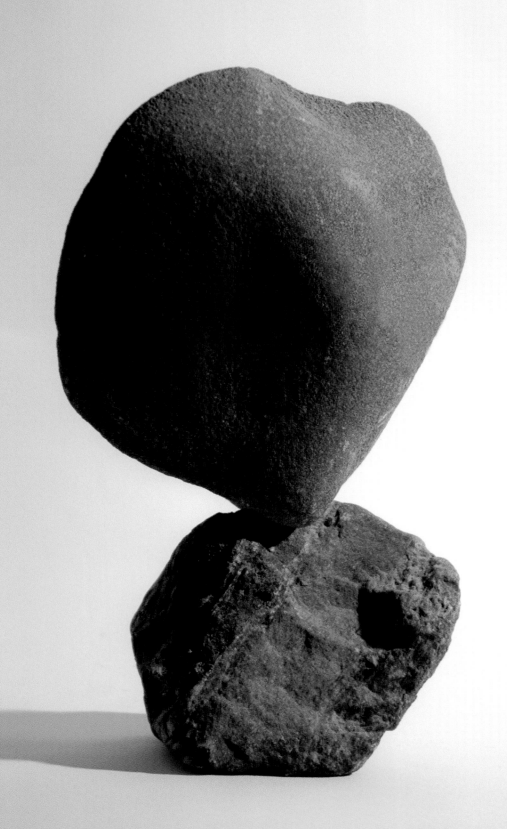

Arp's heart's art

touching stones

Don't touch!—one of the most disappointing signs in any public venue, especially museums, galleries, and other places where "life is scheduled to happen" but at a distance. Yet nearly everyone, especially artists, supports the interdiction as a necessity, though not without some sadness. The core irony is that sculpture is at root an art inspired by touch and, moreover, provocative of the touch impulse. That it belongs to a modality of existence that inevitably betrays its origin by repressing touch tells us a lot about our culture, perhaps culture itself.

Touch is arguably the primary sense, with seeing, hearing, smelling, and tasting as variations on touch. Nevertheless when one of the five senses stands in the place of another there may be some level of sensory deprivation.

When I was a child I had a recurrent dream from which I always awoke strained to the limit by extreme frustration. In the dream, despite an all-out effort, I could not get my hands all the way around a certain object. Although I had my hands directly on the surface, I found it impossible to visualize as a whole, yet it was characterized by the desperate compulsion it engendered in me—*to enter it by encompassing it*. Night after night, during certain periods, I labored to know the contours of this vitally necessary but incommensurable something-somewhere by *reaching*. I both groped and kneaded the sloping sensuous mass that like a mother's breast had no other side, yet seemed somehow to command relentless embrace. This dream haunted my physical world, as though merely by having been experienced, it rendered any object of desire inaccessible.

Many years later, when I was 18 and the dream was recurring only rarely, the whole matter shifted, as if bumped to another dimension. In a museum I spotted a glistening white object, perhaps a foot in diameter, that instantly brought me to my dream. Without hesitation, once the guard was out of the room, I broke the museum law by putting my hands on it. I pressed the cool white stone into my palms, let it move around inside my senses. I felt that sharp surprise of touching something foreign that seemed familiar, almost like reaching inside myself. I felt that, at long last, I was getting a hold on the matter, yet without any

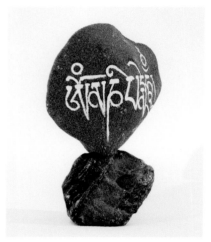

Bhakha Tulku's Tibetan calligraphy of OM MANI PADME HUM, mantra of Chenrezi, the Buddha of compassion.

awareness of what it was. *This* matter—something there on its own, yet undiscriminated, that suddenly takes on importance and now, finally, is beginning to make sense.

Thereafter the dream never recurred. And I've always thought of this outlaw museum experience as responsible for the change. It also marked my discovery of Jean Arp, whose alabaster abstraction was the physical key.

It later has seemed to me that by virtue of this forbidden act—**touching the untouchable**—I crossed a permeable membrane between public space and dream. The latter implies a certain *oneiric necessity* in which art reflects a world that has not yet fully appeared, and even can offer a grammar of ontological possibility. For me this possibility becomes intimate engagement with a stone; at the same time it's a new radical of orientation, beginning with a four-dimensional embrace. I appear (to myself) to be *initiated into* the multiple dimensions of a sometimes self-contradictory or split personal reality, which in the same moment is woven together again.

Obviously this is a story, on one level, of boundary issues, both social and personal. How far does the object's field of identity extend? How

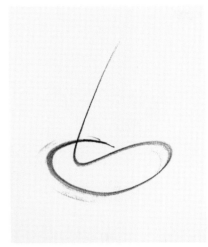

Axial drawing, graphite, 11.5" x 14"
(29.2 x 35.6 cm), June 30, 2004.

far do *I* extend, which is also the question, how far can I go without violation? I'm very aware that, with axial stones, if a viewer goes as far as I let myself go, it would instantly bring the work to an end.

This powerful experience stands behind my strong attachment to **AXIAL STONES 2**, which initially I named *Arp's Heart,* due to an unintentional resemblance to certain works of Arp.

Perhaps too this attachment set me up for a particularly complex incident involving a Tibetan teacher, from the Nyingmapa lineage of Tibetan Buddhism. Bhakha Tulku Rinpoche has been a guest in our house on many occasions beginning over a decade ago. One of his special activities is finding stones, many of them extraordinary, and inscribing on the stone surface a Sanskrit mantra in Tibetan calligraphy. The principal mantra is *Om Mani Padme Hum,* a core mantra of Vajrayana Buddhism. The result is striking. Ordinarily he carries the inscribed stones from place to place and gives them away, a sort of lithic crosspollination, seeding stones with seed syllables.

Bhakha Rinpoche might be described as an indirect teacher, interacting with people most often on a personal basis and in ordinary and informal circumstances. His visits are like privileged incursions by a very intense friend. He's playful, often outrageously so, involving his own species of what might be called *conscious mischief.* He knows where you hide your buttons.

There are many traditions of a related "teacher" in Tibet, often in exaggerated versions like the folk hero Uncle Tonpa, whose mischief knows no limits; and sometimes in exemplary stories that embody a principle, such as the recent invocations of Crazy Wisdom (Chögyam Trungpa's translation of Tibetan *yeshe cholwa*), in which the uncontainable aspect of open awareness shows up as the behavior of "someone who seems to be intoxicated with an un-bounded, luminous, loving energy.... The craziness is actually higher frequency enjoyment." (Steven Goodman)

So the fact that he chose to inscribe a mantra on *Arp's Heart,* and indeed without consulting me, is not particularly out of character. His touching the untouchable stone so as to redefine it, although a sort of mirror of my own youthful action that altered a persistent dream, was very challenging for me. There it was, a core work, converted into a relic, an instant antique, a traditionary religious artifact. This is not to say that the calligraphy is not beautiful, and indeed powerfully so, and perhaps even its own species of "art." However, it rendered **AXIAL STONES 2** no longer just a *work,* and no longer possible to display among the axial stones—that is, unless I erase the inscription. But would I, or perhaps, could I? It's a classic dilemma. And it has brought into focus my ambivalence, not about the real meaning of Dharma, but about representation of any philosophical stance in the art I make. In my practice a work either embodies something or it doesn't; it performs its own principle. It would be less true to say that *I* program *it* than that *it* programs *me.* The axial is a free space, a state of opening, not dogma or ritual. And yet, I still have found myself unable to erase the mantra.

I came up with a plan, still unrealized; namely, to film myself retouching the stone—covering the mantra with pigment that matches the stone, and in the process *writing* the mantra, even as I render it invisible. Its presence here would be a parallel recovery.

a stone in its natural state becomes axial when it mates

truly and perilously with another stone

by way of unforeseeable precarious balance

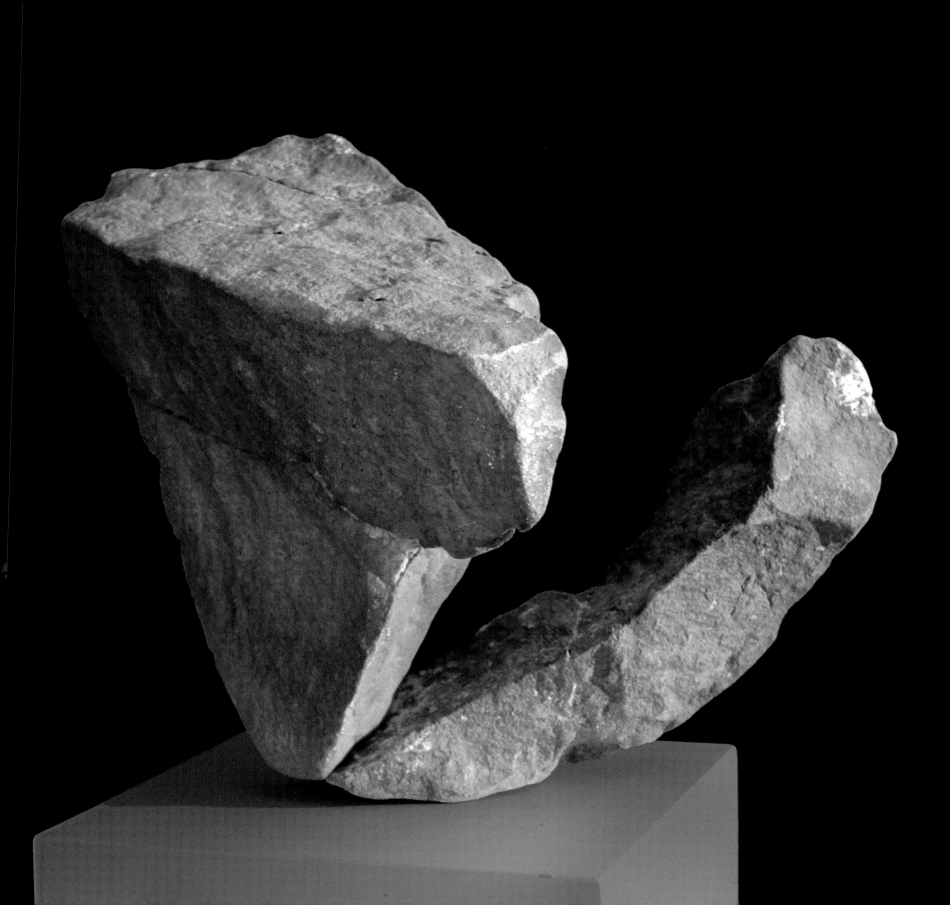

axial music

There are sounds when the stones come into contact. It makes a music of the stones finding a way together. Sometimes it feels as though the grinding is groaning as in labor or sex (they can sound similar). I remember when I was living briefly in Nancy, France, around age 19, with my brother and two friends, a man and a woman about my age, and right after lunch we suddenly heard a woman's loud moaning. I was alarmed at first, as though she was in serious pain and needed help. Slowly we realized that she was having sex and, without the slightest self-consciousness, she was letting her voice resound through the narrow space between the buildings. We looked out the window and saw, two flights below, the huge surging hairy back of the local baker, and under him the flailing arms of the neighborhood storekeeper. It was alternately startling, hilarious, exciting, and disturbing. I couldn't get clear in my own experience, because I kept cycling through those four states. The one woman amongst us was unambiguous in her response—she was turned on. Why was I ambivalent? Was I embarrassed? (I would never admit it.) Later I realized the storekeeper had made a permanent contribution to my sensibility—her unself-conscious wild release in the voice would never leave my inner auditorium. She set a standard. She altered my sense of music.

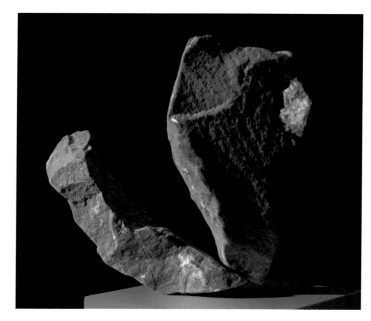

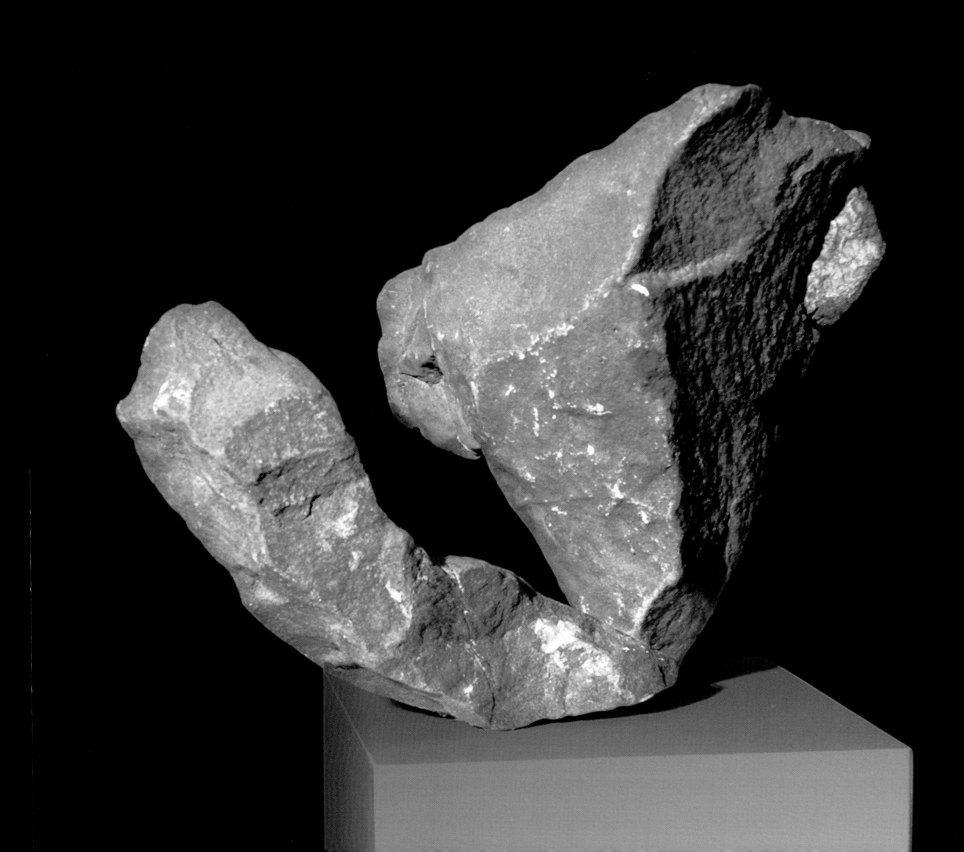

exciting states

It's easy to deny that stones enter into an excited state. *Solid rock* seems the very antithesis of excitement. Do *they* entrain to *my* state?

There's the *phenomenon:* excited experiencing with the stones. If I report that I *feel excitement* when I touch certain stones, the statement itself is *axial:* the feeling is located "in me," "in the stone," "between us." And this *between* is characterized by my sense of getting feed-back through the medium of manual touch. This state of excitement—the phenomenal between of "subject" and "object"—sets me looking for another stone to bring into the contact. Like begets like.

There's a further kind of excitement in being *used* by what can't rationally be accused of *using*. I could not comfortably say (especially in public) that I'm following the *will* of the stone, or two stones, or indeed three stones. Yet when I'm handling the stones, in the curious state of excitement that comes from touching certain specific stones, I behave as though I were following the will of the stones.

I try to get out of the way.

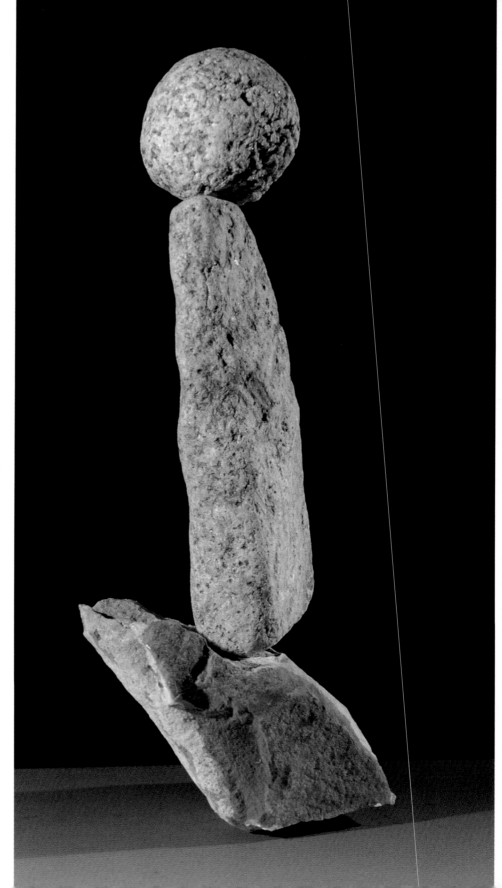

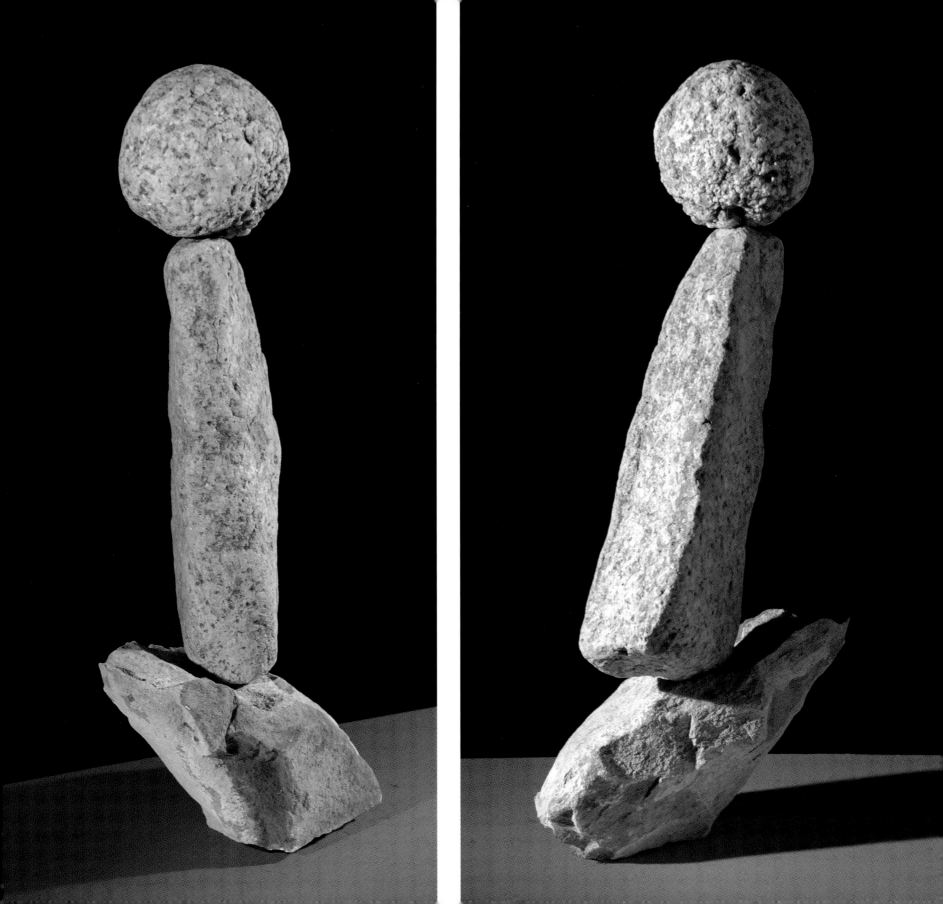

singular stone time turning true tones time out

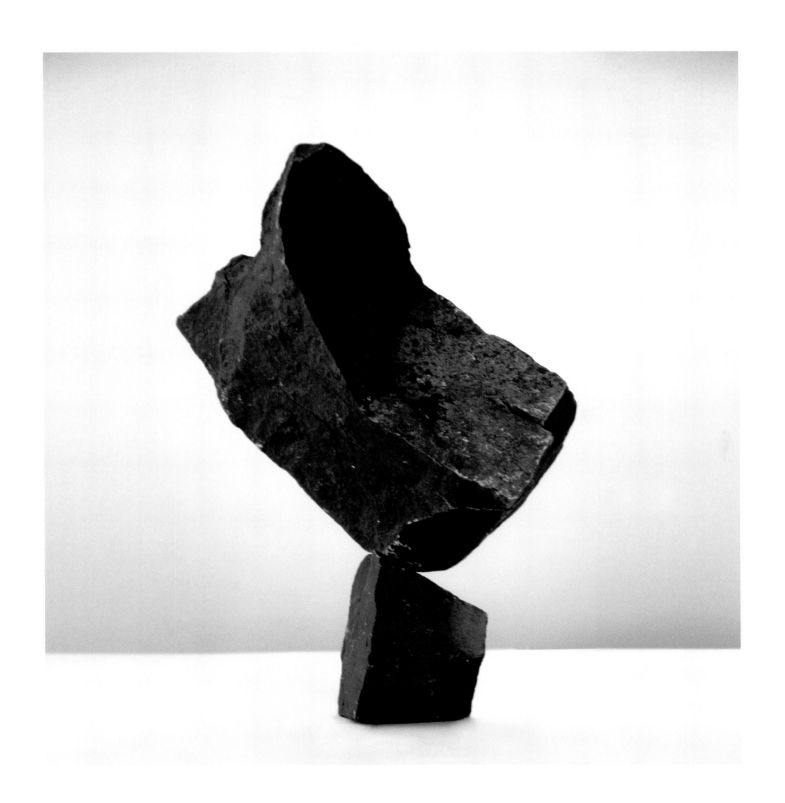

earth organs

These black basalt volcanic stones were brought to me from Mongolia by Jenny Fox, found during her visit there with husband Lincoln Stoller and young son Kiran. They were visiting musician/singer friends, whom they had previously hosted for a performance tour of the US featuring traditional overtone/throat singing and instrumental music. Jenny was also doing some filming for my ongoing work **art is: Speaking Portraits (in the performative indicative),** asking artists (in particular musicians) to say what art is; they answered mostly in Mongolian with a translator—Battuvshin, himself a great artist. Both before and after this I also filmed some of the amazing performing artists they brought to the US, including Battuvshin.

Visiting a Hanui Arshaan healing spring.

Jenny describes their visit to Hanui Arshaan, a Buddhist pilgrimage site with famous healing springs, where foreigners are still a rare sight, approachable via "mostly non-existent roads" some twelve hours from Ulaan Baatar. "A series of springs emerging from volcanic rock substrate line a half-mile stretch of river. The water itself is perfectly clear, mineral-rich, and ice cold. Each spring is keyed to a specific organ or body part—liver, lungs, nose, etc.—indicated by the shape of the rock or rock formation from which it emerges.

Healing spring for "liver" (in Mongolian on stone).

It's as if the human body were mapped onto the geography along the riverbank, corresponding to one's actual body so that a certain resonance can internally guide one on the healing path. (This may resemble reflexology or certain acupuncture models.) Mongolians have come for centuries to walk along the riverbank drinking and anointing themselves with the water, usually carrying containers to drink from each of the springs right at the source. When suffering from a particular malady, one may also leave offerings at the corresponding spring—blue silk scarves *(khadakh),* coins, candy, fruit, snack foods, or fermented mare's milk."

The overall site is *"owned* by a particular kind of poisonous snake, bearing the same yellow and black coloring as local volcanic rocks, or rather the ancestral Snake, one of whose exemplars we were fortunate enough to see there, much to everyone's excitement at this highly propitious sign." Jenny found these stones on the hillside above the springs, where she wandered around until feeling that particular ones "spoke" to her. She liked that "one of the stones had an aperture" and "the rounded end of the other one fit so nicely into my palm." Then she "asked permission of the Snake to take them home, offering a *khadakh* at the main *obo* or offering place, consisting of stones piled around a large branch or dead tree and dedicated to the spirits of the place."

When Jenny brought me the stones I had trouble at first seeing them as other than typical lava—much like what I had seen when climbing Mount Etna many years before—which means I couldn't yet imagine doing something axial with them. As so often happens, my hands discovered them before my eyes, and one seemed to climb up on the other as if to be launched. Then both lifted, the upper stone holding up the lower as much as vice versa. It happened almost casually, as friends looked on, and when it fell into place the room went silent—we all knew it had lifted up into itself.

And that self has dimensions. Months later, when preparing to photograph the stones, I had trouble finding the original position. Staying present through a frustrating time I suddenly saw what was possible, and it *stood further.* Now I could really feel it, like a new organ for an unknown function.

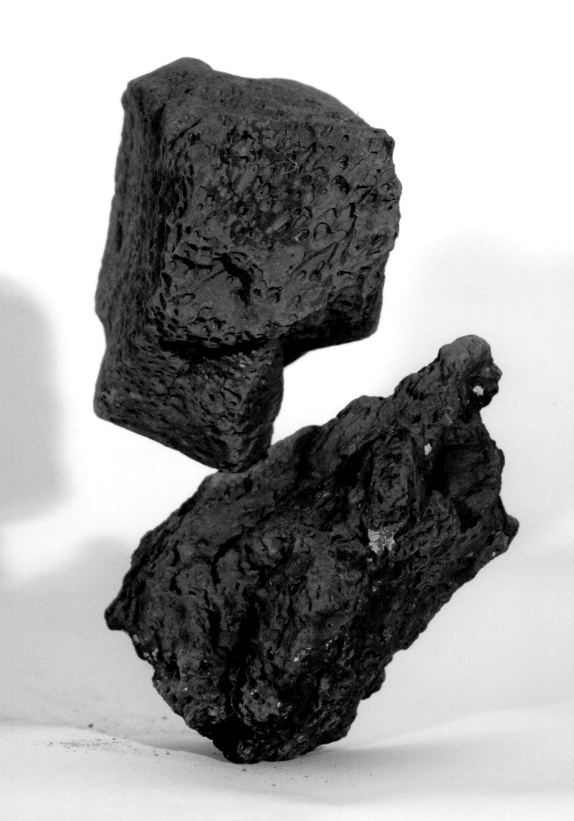

micropolitics

In August 1998, my friends Barbara Leon and Steven Chaikin were traveling in Turkey, visiting Kusadasi, at a stone beach along the rocky coast of the Aegean Sea. Watching the tide passing over the stones, Barbara

noticed a particular stone that "didn't release the sea foam the way the others around it did." She "bent down to touch it, expecting it to be soft and slimy, but discovered that it felt hard and calcified. In the water it was luminous with a bright pale orange shell wrapped around a slate gray core." She picked it up and, despite hesitation about carrying a weighty stone throughout their continuing travels, she bravely decided to take it: "In my heart I absolutely knew that this stone had another place to go, and I was the only way it was going to get there."

This is the upper stone in AXIAL STONES 5—Anatolian, from Turkish Asia Minor. The lower stone is Greek: They took the ferry to nearby Samos, where, in the area of Pythagorea (perhaps in a ruin, she can't quite recall), Barbara found the smaller and much lighter one, chosen, she says, "because of an image of a young boy that was in the hollow of the stone."

A rocky beach on Samos.

Tracking the origins seems at times to map the "intelligence" of axial stones, the transposed genius loci —and the vestigial politics, the ghosts of Hittites, Phrygians, Cimmerians, Ionians, Persians, Romans, Seljuks, Mongols, Ottomans, Turks...any of whom may have left their energetic footprints on these stones. When Barbara first brought me the stones I saw the strange animate beauty of the larger stone beside the condensed gnarl of the smaller one, and quickly thought, "But these two will never stand together." Then I thought, "Hmm, Greeks and Turks."

While we sat in my living room and talked about her trip, I was moving the stones in my hands just to get familiar with them, putting them together in a random sort of way, with inklings of unlikely nesting. I kept feeling that I was holding a head, a wild mountain sheep, lover of cliffs, maybe a mouflon. I thought: *politics, Greeks & Turks, resistance*.... Then almost without my noticing, one stone was on top of the other

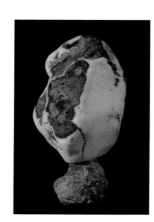

and I was inside the still point, the weightlessness, the sense of rising—it was out of my hands, and still woolly and headstrong, fell into place. An unlikely meeting at the edge, perhaps a portrait of the state of equilibrium between historical enemies—appropriately difficult to bring about. Since then each time I have to reposition these stones, I meet them with apprehension, as if shadowing my original doubt. And yet still, this far along, it appears to happen.

In mountainous terrain, Anatolia.

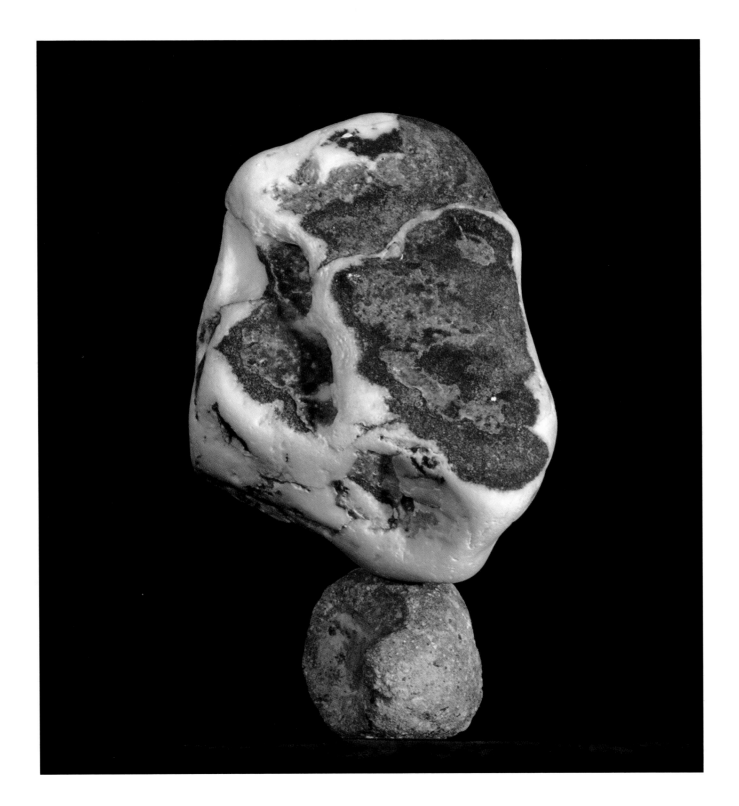

two stones on one edge

surface

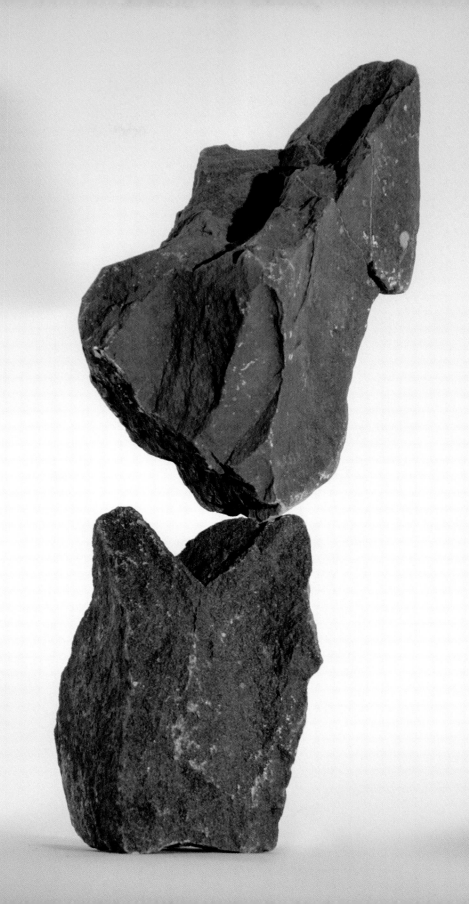

lingam attractor

Barbara Leon describes the interesting way she found the stones of AXIAL STONES 13 in northern Arizona, September of '97, while hiking in Sycamore Canyon, a deep canyon with a verdant corridor feeding off a seasonal river that runs through it:

"In the middle of this canyon there's a large water hole with an amazing bed of rounded stones, among which I found the long stone. Near the shore yet partially submerged, its underwater color was so striking that I picked it up and instinctively cradled it. It had a strong and definite presence.

Field of stones in Sycamore Canyon, Arizona.

"Then walking back I crossed a dry river bed and saw the second stone, nestled in among hundreds of others. Yet it stood out. I was particularly attracted to a 'soft spot' in the center.

"What amazed me was that out of all the thousands of stones I walked over that day I only felt a connection with these two. There was an immediate rightness felt in the heart. I always try to sense whether it's appropriate to take the stones out of their native setting. In my travels I've left many beautiful stones behind because it was clearly wrong to take them. Other times, it feels like a creative event to find them, move them, and transport them to a different place. So far, none have complained."

In this uncomplicated account is something like the whole mystery of the axial stones process of discovery. No agenda, no effort, no doubt.

There's the *field* that one enters. And obviously there's intention operating at some level, however indirect or residual. In this case my work with stones in general motivated her to carry those stones a long way out of the canyon and then over to me. I and/or my work comprise a *hidden attractor* in the field, and it's interesting to track a *projective intention* with a trajectory beyond my own immediate activity, engaging certain friends in similar ways. There's a spontaneity, clarity, and certainty in her process that reminds me of my own experience with the stones.

One can think of the field in terms of chaos and Barbara's wakeful presence as *strange attractor* calling particular stones into a new alignment that resonates as far as Barrytown, my work there, and then this book, wherever it goes. It generates unique events. As one fractal website puts it, "Like snowflakes, these strange attractors come in infinite variety with no two the same." So too the stones and their axial "dance of Shiva," as the present configuration suggests—the lingam and base or yoni, surprisingly "traditional" in form—by no one's design. In fact, when Barbara brought the stones to me, we all doubted that they would go together, and then suddenly it stood, lingam in place.

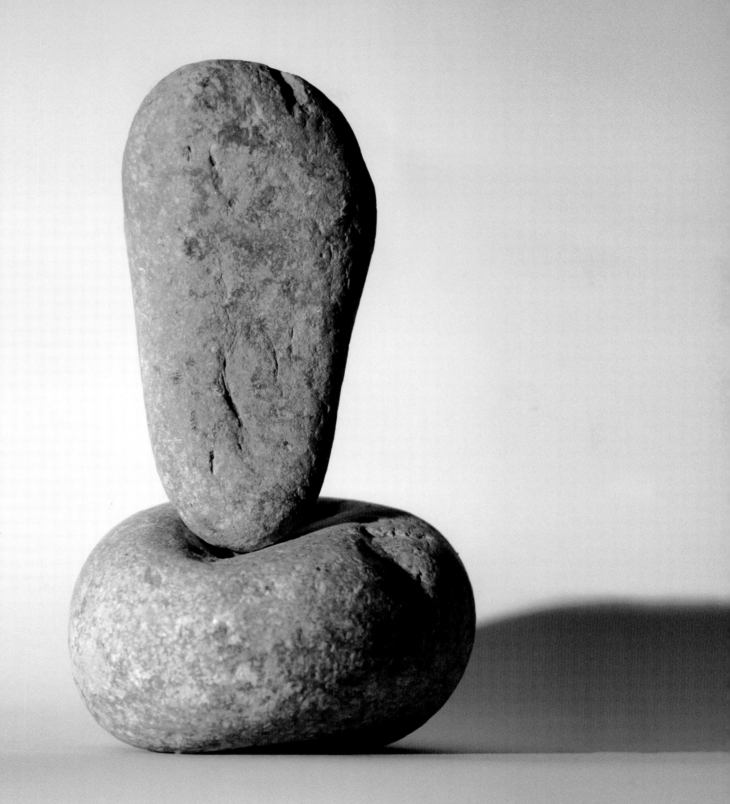

spiral

As I looked at the site, it reverberated out to the horizons only to suggest an immobile cyclone while flickering light made the entire landscape appear to quake. A dormant earthquake spread into the fluttering stillness, into a spinning sensation without movement. This site was a rotary that enclosed itself in an immense roundness. From that gyrating space emerged the possibility of the Spiral Jetty.

No ideas, no concepts, no systems, no structures, no abstractions could hold themselves together in the actuality of that evidence. My dialectics of site and nonsite whirled into an indeterminate state, where solid and liquid lost themselves in each other. It was as if the mainland oscillated with waves and pulsations, and the lake remained rock still. The shore of the lake became the edge of the sun, a boiling curve, an explosion rising into a fiery prominence. Matter collapsing into the lake mirrored in the shape of a spiral. No sense wondering about classification and categories, there were none.

—Robert Smithson, "The Spiral Jetty" (1972)

When I was invited to give a talk at the Salt Lake Art Center in conjunction with an exhibition of Gary Hill's work, I also presented my ongoing video work **art is: Speaking Portraits (in the performative indicative)** and continued there to film artists doing what more than 400 other artists so far (in six countries and seventeen languages) had done before my camera—namely, say what, in their view, art is. It felt especially right to be doing this so near the place where 34 years before Robert Smithson had made a work that profoundly challenged the sense of what art might be. I was excited at the prospect of finally getting to visit the Spiral Jetty, aware that after decades of being submerged under salt water it had *risen!* And now it was *white* like Moby Dick or, more aptly, a coiling serpentine Naga—encrusted with salt—instead of the snaking black basalt familiar from photos. Jim Edwards, Curator at the Art Center and guide extraordinaire, fulfilled his promise to drive me to the Jetty, more than a hundred miles north of Salt Lake City, "out on the range" of open grassland and sagebrush, and over some challenging rough terrain.

Reading Smithson's text about the site and visiting it become inseparable experiences—they bleed into each other. He wrote of choosing this particular place on the north end of the Great Salt Lake, Rozel Point, because of the roseate tint of the water (the competing site in his mind was in Bolivia), here caused by salt-tolerant bacteria and algae (also brine shrimp)—blood of the earth. You can't help but feel an artist's reigning psyche who marked the land so definingly, texturally, textually—and *anciently,* like a giant spiral petroglyph—written in stone written in water. Permanence within impermanence. And written too in the blood of a poet, which of course Smithson was through and through, whose works are always also language acts, wherein the domain of language shows itself to be pervasively *matter,* and elemental. Turns of the sentence, turns of mind, turning with the Earth: the spiral superimposition.

Above: The Spiral Jetty as it looked in March 2004 after decades under Salt Lake, the black basalt almost white in Ray Boren's photo.

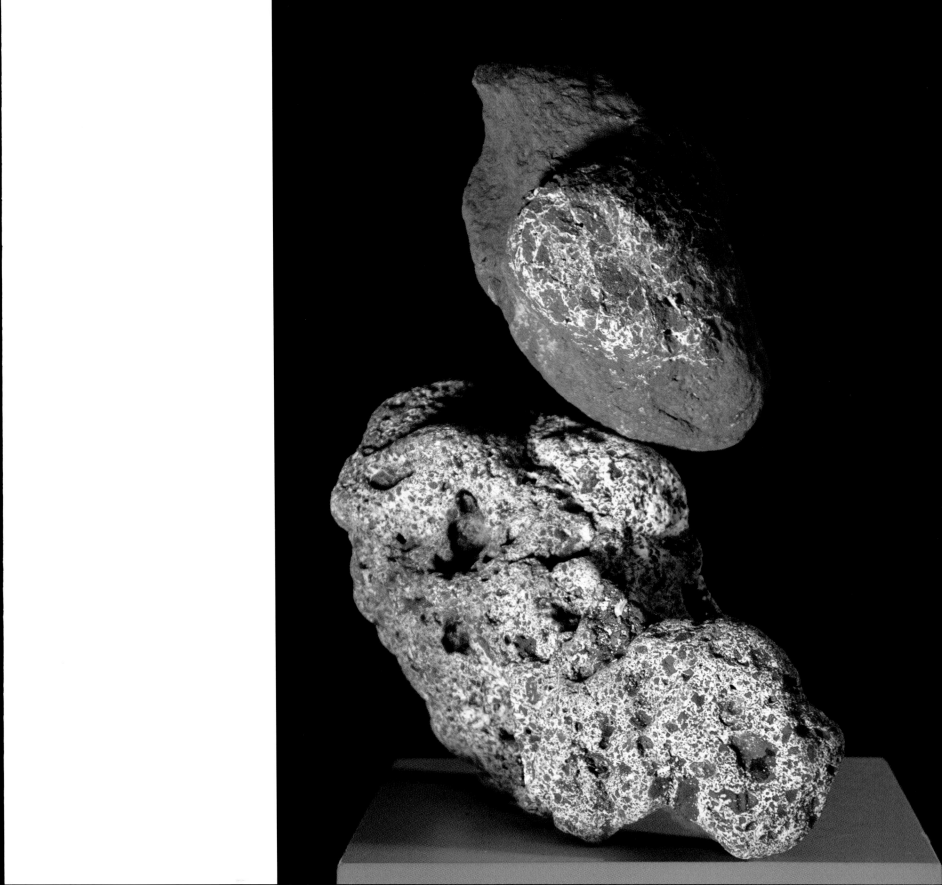

Smithson says further:

The scale of the Spiral Jetty tends to fluctuate depending on where the viewer happens to be. Size determines an object, but scale determines art. A crack in the wall if viewed in terms of scale, not size, could be called Grand Canyon. A room could be made to take on the immensity of the solar system. Scale depends on one's capacity to be conscious of the actualities of perception. When one refuses to release scale from size, one is left with an object or language that appears to be certain. For me scale operates by uncertainty. To be in the scale of the Spiral Jetty is to be out of it. On one level the tail leads one into an undifferentiated state of matter. One's downward gaze pitches from side to side, picking out random dispositions of salt crystals on the inner and outer edges, while the entire mass echoes the irregular horizons. And each cubic salt crystal echoes the Spiral Jetty in terms of the crystal's molecular lattice. Growth in a crystal advances around a dislocation point, in the manner of a screw. The Spiral Jetty could be considered one layer within the spiraling crystal lattice, magnified trillions of times.

Texture of Spiral Jetty's salt-coated basalt in **AXIAL STONES 24**.

This verbal object, his text and, in fact, his own read-out of an imaginative seizure of the spot, determines the interactive event of one's own sense of scale at the site. And this enacts further the event in the original quote above, where we feel the Jetty being birthed by the site's spiraling energy, inscribed here. The ancient petroglyphs he studied are writ large, and cut right into the earth, bleed its meaning, taking color from residual life inside the water. And here the liminality of art forms—earth art and text art *as* each other—reveals the axiality of the site itself, how our perception of it, our scaling of experience, enacts a primordial event that is not separate from our presence. Between site and nonsite is the *recited* site of language.

Walking the area around and indeed on the Jetty itself is an up and down affair—basalt under foot, the black porous volcanic rock that is everywhere and offers the most immediate contact with palpable earth history. So the compelling sense of scale is *by foot*, whether climbing up the black boulders to get the amazing elevated view or spiraling out and in counterclockwise, as if to a wave tip inwardly held.

The artist photographed by Jim Edwards on the innermost loop of the Spiral Jetty filming, in real-time, his walk in and out.

As a sort of homage to Smithson's film *Spiral Jetty* (1970)—a third work in his set of liminal arts that includes the earthwork and the text—I chose to film the real-time journey out from land (into the spiral out in the lake) and out of the spiral (back onto land). It's a trip along the causeway to *within*, heading nowhere *slow* but into the matrix of a wound-up spring, concentrating energy toward the release of an alternate Real Time. The winding directionality is an experience of axial orientation—the axis at once your own, the Earth's, and the art's—which effectively rescales time itself. You sense how history

and earth layer each other. And *chemistry*—crystals of salt disposing the light, color, texture—the wavering atmosphere altering the landscape moment by moment. As Smithson puts it: *One seizes the spiral and the spiral becomes a seizure.*

Smithson's spiral is scaled to the human. It's scaled *down* from the grand panoramic rotary force of the whole visible field of sky, lake, distant mountains. It's scaled *up* from the human body and its hands-on work—like petroglyphs, text. And it's *variably* scaled by shifting perception and transformative interaction with a shape-shifting site. The Spiral Jetty's environment is a powerful instance of natural alchemy—changing gradations of watery red, dramatically varying moods of light and sky, and the huge impact of water *level* change, from significantly resizing the Great Salt Lake to determining the fate of the Jetty—which at the time of this writing is once again *back underwater!*

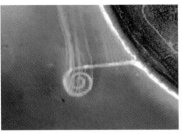

Satellite image of September 14, 2002 showing the drift of salt over the surface of the water.

An art in layers with precarious equilibrium: the artist takes up the energy of the place and lays down its force as rock on water, revealing strata of earth, history, and mind. And then it all turns back around.

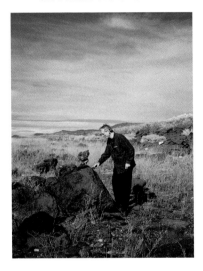

Many of the stones I find come from water—rivers, waterfalls, lakes—and are clearly water-earth shapes, already the record of ancient flow and its spiraling force. And water is essentially itself a twisting liquid force, although the heaviness of Salt Lake slows it down. A circulatory system of the planet, flowing water spirals along its driving path, going where it can and ever moving towards becoming a circle; rivers meander and defy straightened banks, often wearing through their bounds and going astray; and sometimes a river cuts loose over time to form an outside circle which, eventually flooding, creates a backwater—a miniature lake, the bastard child of a wily waterway. And these are microcosms of the grander Earth processes, which can be read back through the shapes of stones. A stone, as I relate to it, is a massive, prehistorical Earth event that more or less fits in the hands. I claim it on the scale of what I can lift.

Walking the Jetty and surrounding area, one is most aware of black basalt boulders all around, 6,650 tons of which, mixed with earth, Smithson used to construct his 1,500 feet long by 15 feet wide spiral—his sense of scale during six days in 1970 requiring the use of two dump trucks and a front loader. The rock derives from local volcanic eruptions of the Pliocene (two to five million years ago) and so is an Earth record of violent birth by fire. And since the 70-mile-by-50-mile Great Salt Lake is the distant child of an ancient, far greater freshwater body named Lake Bonneville, every stone in the vicinity is further shaped by water. And then there's the salt. Like the Dead Sea, a human body won't sink

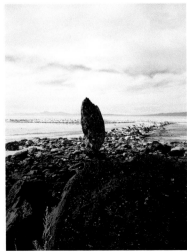

Above and below: The artist on the shore outside the Spiral Jetty and the basalt stones he balanced there.

in Salt Lake, as we found out when Susan and I went swimming near Salt Lake City around the time, unbeknownst to us, Smithson was creating the Spiral Jetty. It's a strange outerspace sensation to float so freely, no will in the matter, as if gravity reversed.

As Jim and I were leaving the Jetty I couldn't resist picking up smaller stones around the peripheral rocky beach and balancing them in brief homage. Two of them came into my hands with a special clarity. I knew right away they were going home with me.

It wasn't till some months later that they went suddenly into action and showed their axial force. And in a flash it all seemed to come back into presence, the whole journey along the contour of an inwardly flowing wave, somehow captured in the turning earth right there at the surface. You take it up in your hands. It makes you feel their intelligence, the hands, the stones. It's this neutral subject felt in the still point, seemingly the same spiral surfacing anew. Scaled down, surrendered to site-specific gravity, to allow a front lift of the stone to a wave crest of spiral levity—the event at hand: a unique stone slowly turning to mirror hearing.

these stones speak for themselves

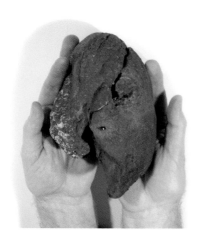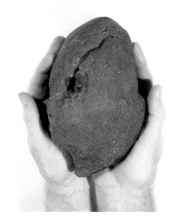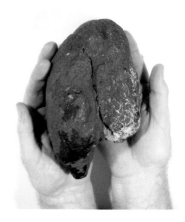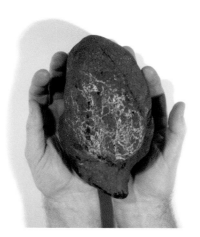

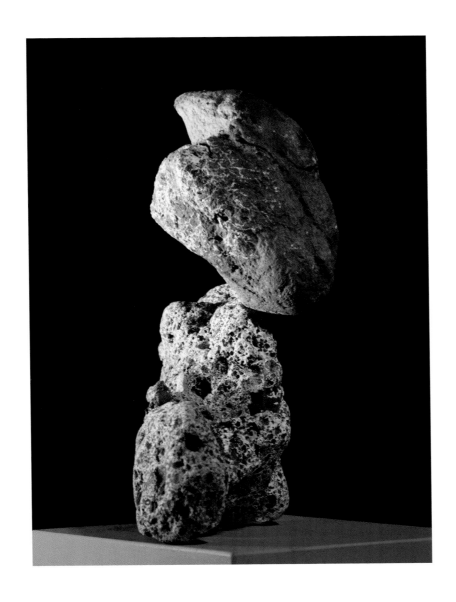

viewing touching

viewer is touched

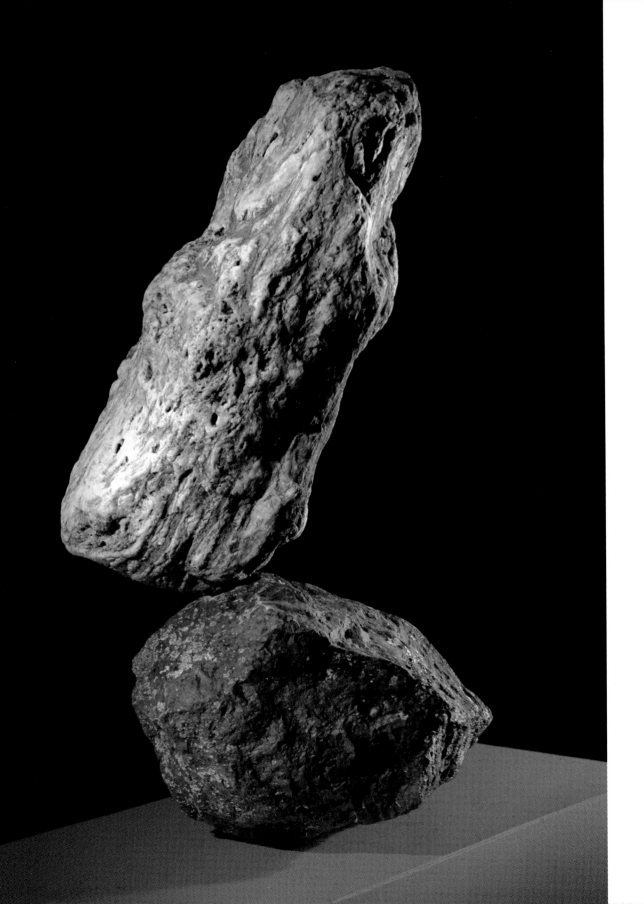

what is stone?

"Concreted earthy or mineral matter; rock." Maybe.

There's the difficult to define, even somewhat mysterious, substance represented by the word "stone," and then there's the ambiguous, comparably mysterious, "substance" of the word itself. *Stone.* I can't call the axial stones "rocks." It's not that I can't *ever* call the happenstance objects on the ground *rocks,* but once I pick one up, feeling the attraction to this particular one, with the possibility of working it axially, it can only be a *stone.* Why? I've been wondering. Anglo-Saxon vs. Latin? Possibly. I admit a common affection for the Old English root—as Blake named it, "English, the rough basement." *Stan,* rather than *rocca.*

Perhaps it's the sound: *stone.* Sibilant plus *tone.*

Like a rounding in the hand that holds it, the tongue that calls it.

If you look at a Jean Arp alabaster sculpture you think of it as stone, not rock. The fit of the hand that touches it is almost lingual.

Stone seems to generate a corporeal syntax. Stone hands stone.

It allows for a certain intimacy. Or a certain openness in the relationship to the object, to the connection of object to object, and to the question as to the nature of the object. Why? I'm not sure. (Indefinite phenomenology.)

So what is *stone?* The word does not have the same status as, say, *granite,* which takes the mind to something exclusively its kind, defined by composition; e.g., "a common, coarse-grained, light-colored, hard igneous rock consisting chiefly of quartz, orthoclase or microcline, and mica"—and granite is a kind of *rock.* The stones that I work with do not call my mind to their geological category or chemical composition, although I inadvertently register the obvious content. And lose that focus immediately upon the touch.

Nor is stone quite like its elemental parallel, *metal.* In the Chinese Five Element system metal is an element, as is wood, but there's no air. If *metal* and *wood* (which we, deriving from the Greeks, would subsume under *earth)* are elemental, why isn't there a system in which stone is an

element? After all, the element of elements, so to speak, in alchemy is the Philosopher's Stone, the agent of transformation by which a gross substance becomes precious and pure. Or anything becomes anything further. Stone feels elemental.

The question *what is stone?* is a linguistic act within a context. It quickly makes one consider, and shortly reject, science as such. Perhaps we need for stone a Gaston Bachelard whose meditations on fire and water generate a reverie-based phenomenology. Or a poetics of stone, on the precedent of his *Poetics of Space,* the inside view. A motivating question might be: how does handling these stones situate me in this space so that it (the space itself) wakes up and I get oriented? *I placed a stone in Tennessee....*

Is the question of the same order as the question "what is flesh?" *Flesh* retains the range of its many meanings very close to the surface of the word— soft tissue, human body surface, the meat of animals, the edible part of fruit, the body as opposed to mind, human carnal nature, sensuality itself, and so on. At the same time it has complex resonance in the course of usage, which causes us to use it with care, because it seems to "touch" us on so many levels. Certain words have a strange power to quickly get "under our skin."

At work on **AXIAL STONES 32** in the Stained Glass Studio; on the right, **AXIAL STONES 10.**

Stone would probably not seem that way to most people. Yet for me it is that way, and no doubt the emergence of the axial stones is largely responsible. Other people have this sensitivity to stone more naturally (I think first of Susan and Chie). The "poetics of stone" might address the way that sculpture— especially for me, axial sculpture—does for stone what poetry, for many, does for language, the "word made flesh" phenomenon.

Things that call out the act of touching: stones invite touch, yet axial stones defy touch. They force touch and the presence of the other to go "inside" the perceptual engagement, and to work on a different plane, which is constituted by each act of viewing.

Just as axial stones have a newly discovered and radically particular axis, so the act of viewing must find its axis in each moment, to take the place of touch. Seeing is fueled by instant touch deprivation. Viewing becomes touching, touching viewing.

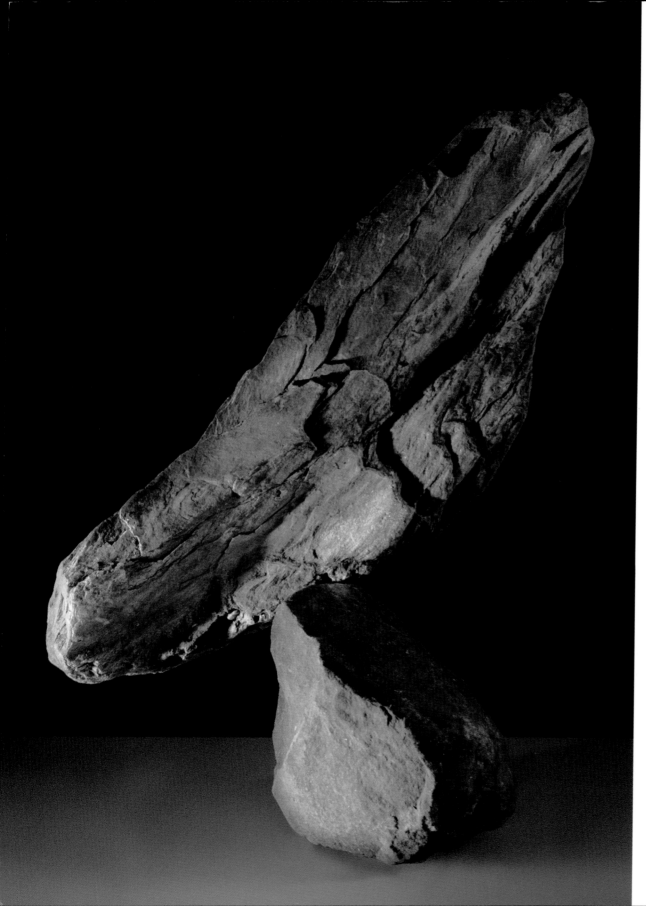

stones

to listen

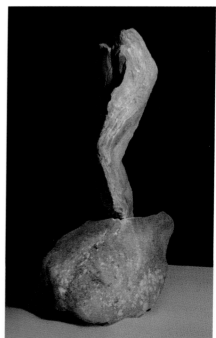

appear

for you

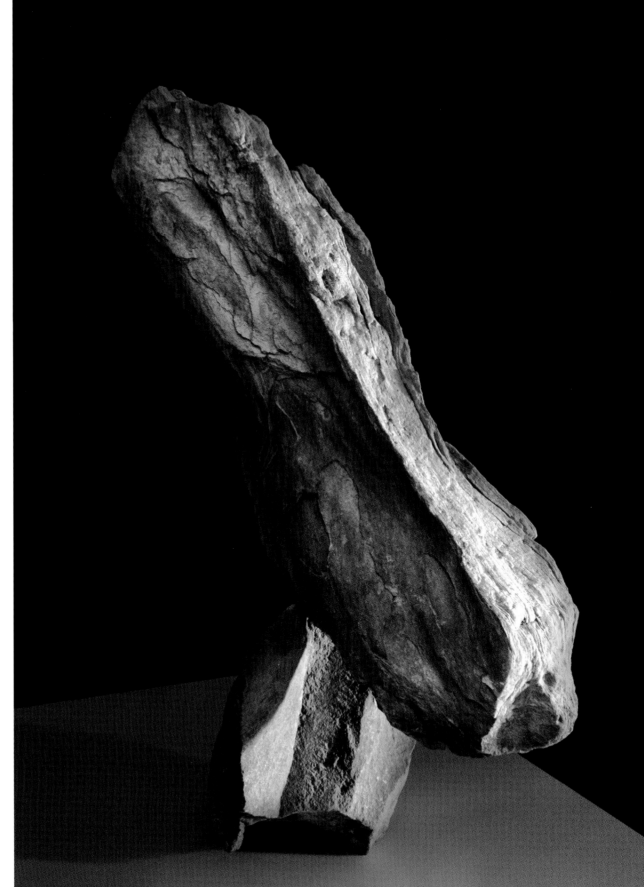
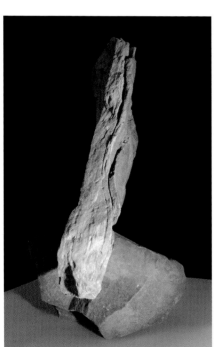

used stones

Driving home after dinner in Rhinebeck recently, I mentioned to Gary Hill that it's impossible to find "used car" dealers anymore—only "pre-owned cars." "Used" must have used up all remaining good will and retains mainly the sense of "lemon." I wondered if it would work to open a dealership for "experienced cars."

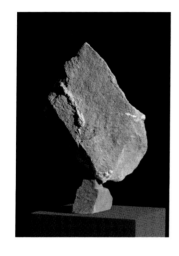

I was amused the next morning to run across Robert Ryman's old story about getting his painting on paper through German customs without paying the "art tax" by calling the works "used paper," which apparently worked. This made him think of "used paint," "used bronze," and "used canvas." Even if its origins are tax evasion, it does honor some interesting meanings of *use*. But I like even better Irwin Kremen's use of *experience* in speaking of the bits of paper he finds in the street as "experienced paper." It makes for rich qualities in his collages, which are usually quite small yet in their powerful impact seem to contain something like compressed heat. The sense of experience there is that there's an actual *charge,* in part the property of experienced paper, in part the artist's refined composition—a listening to the papers to find their fit—that draws the energies into play. When we exhibited together at Cotuit Center for the Arts in Cape Cod, we both saw that there was something complementary between his collages and the axial stones, although the sense of composition is apparently very different. I think it may be partly in the way his papers retain their original charge, as of course stones do. Experienced stones. Even a small stone is the trace of a vast Earth history. It also retains the energy of recent habitats. And once they enter a more obviously intentional "relationship," there's further use on top of long experience, the grinding and wearing, the random marks recording a certain violence of contact, where they definitely look *used.*

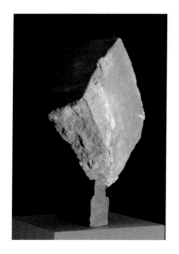

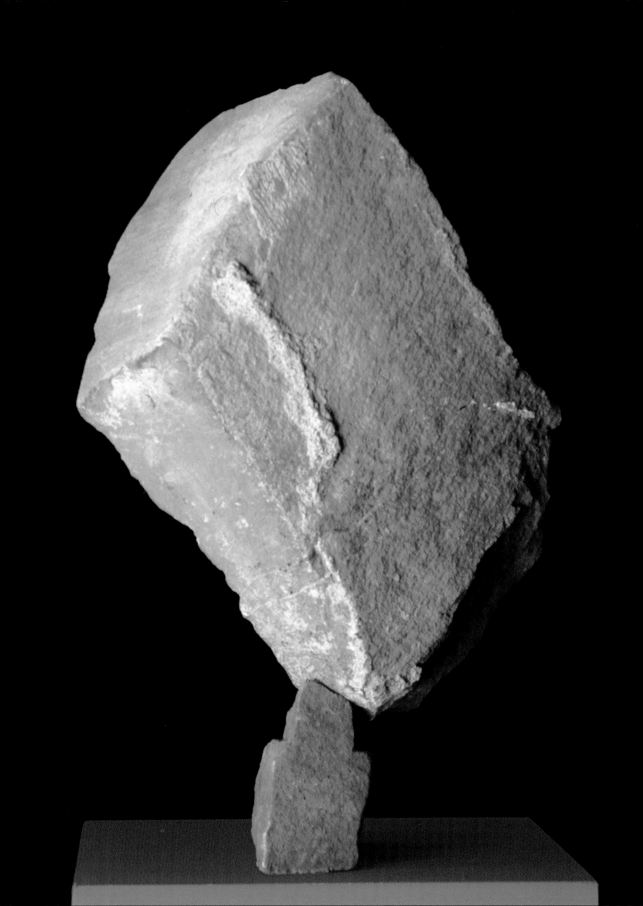

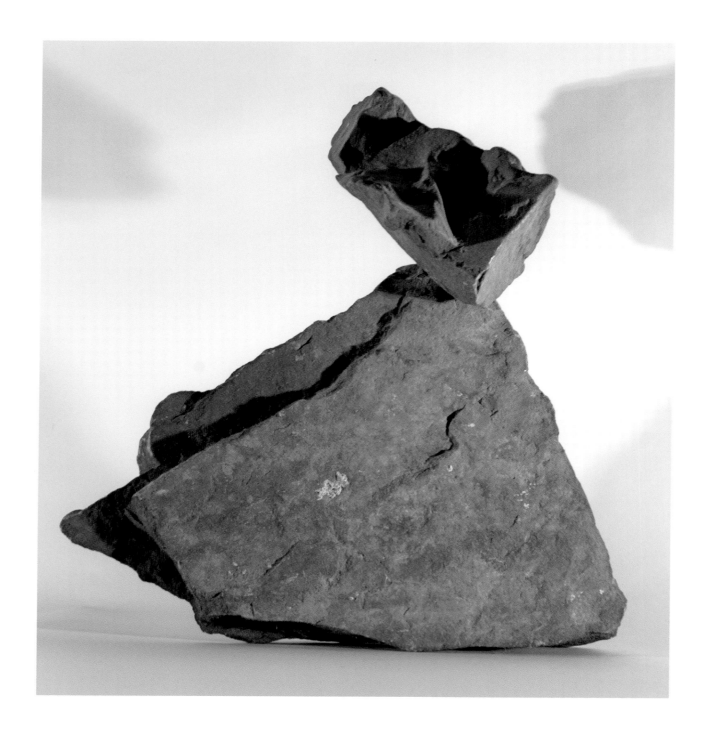

thinking itself

up

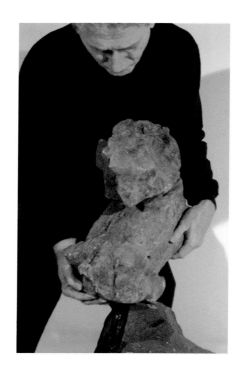
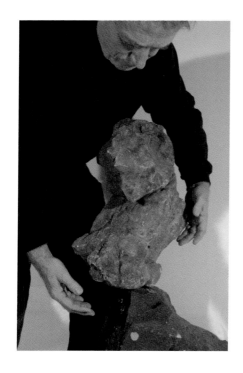

why two hands?

One day many years ago, when Susan and I were driving along the coast in Connecticut, we stopped to watch the waves breaking against a jetty. It was night with a bright moon and clear stars as we walked out along the land projection to feel ourselves in the midst of the waves. I got caught up in watching the waves and following one wave after another as each approached the extensions of shore. When the wave hit the jetty it divided into two, yet the connection to the original wave somehow remained. Was it now one wave or two?

Contemplating this question while watching the actual waves had a curious effect and led to a sudden realization, which registered inside my body and which I could only articulate by imitating the flowing, breaking wave with body and hands. A wave moves onward, in this case reaching toward the shore; it hits an obstacle that divides it in two; the two waves move now on separate paths, yet they retain the integrity of the larger body of water that links them. It sounds simple. Yet tracking the phenomenon with one's body can produce an experience of "integrity in division": a state of inner movement in two separate directions retains the guiding force of a "deeper" unity, literally below the surface in the body of water.

We understand this sort of phenomenon intellectually and with cognitive facility, and yet we may fail to grasp it in ways that matter in actual practice. This might suggest that the very "cognitive hold" on the event—the way we situate it rationally—may even impede the next level of realization. And in fact we are so advised in the Taoist practical traditions. I recall a famous description from the t'ai chi master Cheng Man-Ching, with whom we began studying in the early '70s. He said that he never really understood the t'ai chi martial art of push-hands until one day he had a dream in which he had no arms. Like all martial arts, the arms are critical to the push-hands practice, yet the actual sensing of the opponent and source of responsiveness come not from the arms as such but from the body as a whole; in particular, accurate sensing comes from the "energetic center" or lower belly (the *tan t'ien* in Chinese, meaning "forge," or *hara* in Japanese), regarded as the storehouse/distribution center of energy. In general the many available counselings on the openness of mind and body can be interesting without, however, adding much to one's actual understanding in practice. One might be wary of a sort of Charlie Chan syndrome of endless "deep" statements that lull rather than excite the mind. Minus the Chinese hero's humor. "Talk cannot cook rice."

So why two hands?

There's the mysterious situation of two hands having an almost untrackable way of being independent of each other, with separate functions, and at the same time completely in harmony, in agreement. How does one brain track two extensions? A veritable emblem of human disorder and irrationality is embodied in the question, "And if the right hand does not know what

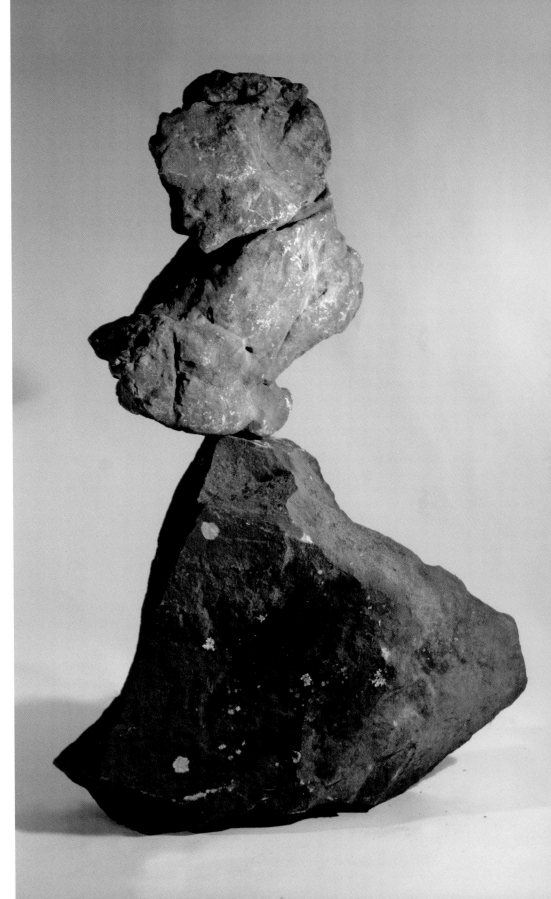

the left hand is doing?" This could seem the very image of chaos. Such fundamental "truth" is the stuff of half-understood proverbs and inevitably the focus of mysteries, as in the tortuous sayings of the non-canonical Jesus of the Gnostic *Gospel of Thomas:* Jesus said, "It is to those who are worthy of my mysteries that I tell my mysteries. Do not let your left [hand] know what your right [hand] is doing." A lot would seem to hinge on the meaning of "know," since there are many orders of knowing, and one of the most basic is the question of what it means for *oneself* to be *two*.

Or: whence the *knowing* that one hand has of another? Is it the head, or brain, that controls the dominance of one hand over the other? Or maybe it's the *view,* the prejudice, that such decisions are brain-centered, even cognitive, rather than body-centered? (Perhaps the Gnostic Jesus, historically disinvited from the Christian table, registered the problem of anatomical hegemony: the head as supreme leader of the body.)

One (oneself or one self?) has two of some of the most basic things: hands, feet, eyes, ears, nostrils, gonads/ovaries, sides of the body, and hemispheres of the brain. And "we" have our differences; that is, we *different people* (you and I) and we *people who differ within ourselves* (me and me, being of two minds about so much). Yet mostly all these "we's" get along, playing down the differences and keeping in place a reliable division of labor in a body possibly divided against itself. Very practical.

Yet one—that is, oneself who has "two of everything"—has the option of disrupting the system. A right-hander, I can suddenly start eating (or batting) lefty, at the risk of inelegance (or striking out). Dr. Moshé Feldenkrais argued, on behalf of his famous Method, that intentionally altering such ordinary left/right habits can have a major, indeed liberating, effect on consciousness and the brain. The mind-body is put on alert that what is most automatic—even autonomic—is subject to conscious change. In short, messing around with the *two that is one* changes the *one that is two*.

The haunting question is: can altering one's dependence on side dominance in body and mind impact our dualistic predisposition toward hierarchy, gender and class dominance, and the social-political pattern of hegemony? And can we reflect such a dynamic in language and thinking?

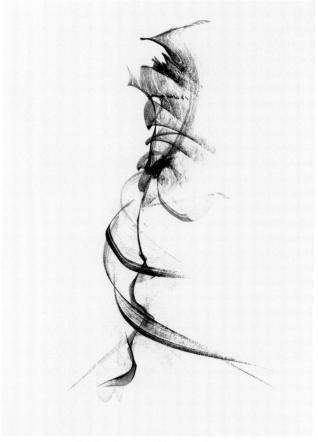

Axial drawing, graphite, two-handed,
18″ x 24.5″ (45.7 x 62.2 cm), August 8, 2005.

When thinking of the "one wave," for instance, "breaking into two," does the one stand in opposition to the two? If not, what is the alternative? Or is there a non-answer—that is, *not* an *alternative* as such—that satisfies the question? If I say the *one* wave is non-separate from the *two* waves generated upon hitting the jetty, this "one" is not the same "one" as in one hand *vs.* two hands. It's not a one as *opposed* to two. It's a one that at various times may be said to *include* two, to *express* as two, to consist at once *in* and *of* two. It's the one that says that two is any number greater than one, as in Goethe's Faust speaking of "the two souls in one breast." The multiplied manifestation is not a thing as such but a very specific dynamic existing only in its moment and leaving, at best, a certain trace.

In this way of thinking, the two waves formed upon contact with the shore are *liminally* the same; that is, there is a constantly shifting threshold of "identity" between them. They retain some essence of each other in their evolving independence, all of which is "controlled" in the moving center of the body, the axis, requiring a surrender of the "head" to the "field."

In a world in which *one* is not *opposed* to *two* but in various senses always non-separate, there is an active threshold between independence and interdependence. Perhaps we are only liminally separate from each other in the first place.

Accordingly here is my speculation about "why two?": The *function* of the two hands *alters* when they *reflect some direct awareness of this liminality*—or at least that was my discovery that night along the shore as I registered the way the one wave became two. Thinking, as it were, with my hands, I let the action move to the center of the body, not as a control center in the way the brain tends to be, but as a point where the two hands are in dialogue and respond to each other. Not merely doing the predetermined work of the "body chief," the head, but working together openly and even perilously.

This could be one way of understanding the famous yin-yang symbol of the Taoists. More pertinent to the axial work, it stands behind my choice to draw with two hands simultaneously.

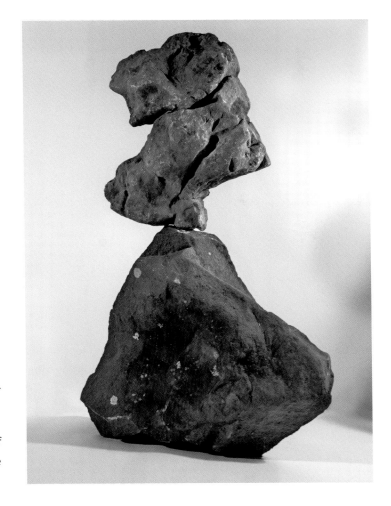

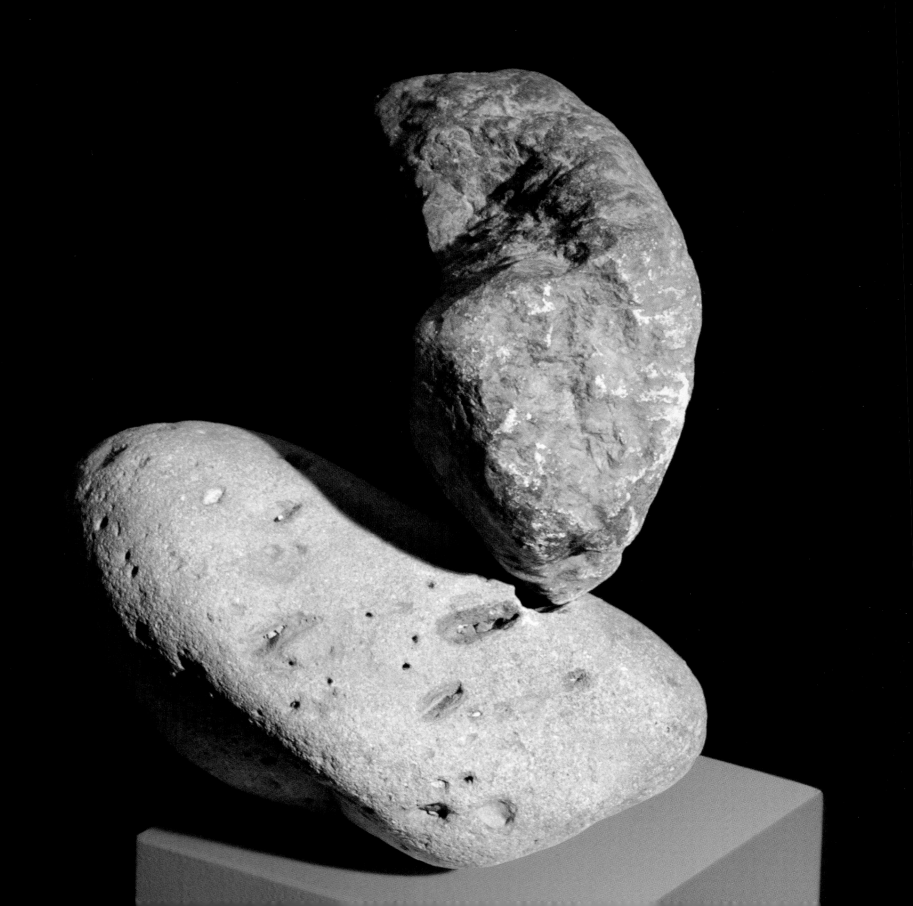

re

quest

the

art

to

draw

back

into

its

question

seeing body

Letting eyesight fall back from the forefront of perception gives rise to alternative modes of *seeing*. The body sees, and probably does it better engaged as a whole. With axial stones the first problem is how to find the empty center where the stone becomes weightless. Yet the eyes stay active, and so the second problem is how to keep them from dominating, from being "masculine" and overly concretizing. From interpreting, and then holding on to the ideas.

AXIAL STONES 7 became material to this question. Sometimes when you get close enough to a stone you see it as gendered. Of course the distinction is not solid. Its ambivalence points to how much gender itself is configuration, and how often *optional;* after all, in situations of physical ambiguity or androgyny, even sex can be preemptively decided at birth by physicians. And to the extent that sex, like gender, is social and cultural, it's open to reconfiguration. While gender is intrinsically axial, *living* gender axially is socially marginal at best. The convenient distinction sex/gender (genetics/culture; indeed, nature/nurture) is a fundamental instance of radical liminality.

Once this upper stone found its position, it took on gender: *she* bears signs of an age when the planet was in a fluid state. Her features trace a time of the river turning into a waterfall. Now she rests here on a flimsy ledge of sheer surface friction, a minimal grip, and a kind that is rarely satisfactory for axial stones; eventually it will fall, due to accumulated normal vibration that causes gradual slippage. Yet this has happened only once in seven years. It's a sad day when she falls. Just recently a friend accidentally walked into her, and she drew blood.

When we first found her, just off the edge of land in the headwaters of Bash Bish Falls, I didn't see her features. I never look for that kind of configuration, and in fact I try not to see it. It's distracting, and once you see it, you can't easily forget it. Yet time configures all by itself, as in long relationships, where it can take decades to really *see* one's closest companions. Stones see in millennia.

So, what is *she* doing here? And how did *he* end up under her, preverbal?

Now *I* configure. No point in resisting her, since she makes no claim on reality. Her gaze out of stone is not stony so much as parasexual, *ur*sensual, and from an unknown side of passion. Pointing upward, yet heavily grounded; lightly poised on her empty axis, yet precariously gravitating—she stands as dream, motionless, emotionless, yet on the timescale of stone, excitable in mind alone. She is dreaming a planet possessed first by women. Men are trying to find out how to relinquish their stony claim on history, their hold, in fact, on the current of living energy. The idea that men are somehow capable of giving birth appears in the upper stone's rising from the Zeus-like head below. Or maybe she's saying that history changes in the loosening grip. That the life of the river, the flow, creates the rocky way, etches the longlasting features, lets hard things find their optimal equilibrium for the time needed—and fall back to Earth.

I imagine her behind a poem of some years ago, clearly coming from outside my active poetics, and, so, leaving me no basis to refuse it here:

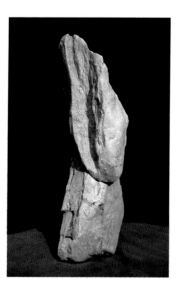

stones

Stones are only visiting us
here in the realm of perception.
They have a time
deeper than time.
They sing
quiet. They hold
space open
for shadows
and tilt the continuity
of the empty view.
They point
in the direction of around
and about
but not for
anyone.
They appear to long
for unborn selves—and lean
against thought.
No feeling is at home among them.
No touch touches
except itself.
The found stone is sleeping
as wide
as awake
and takes away the need to stay
too long.

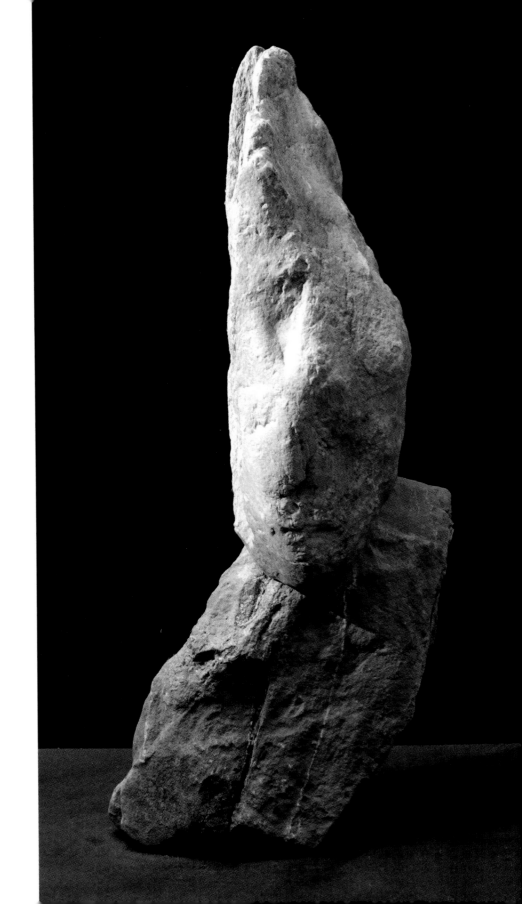

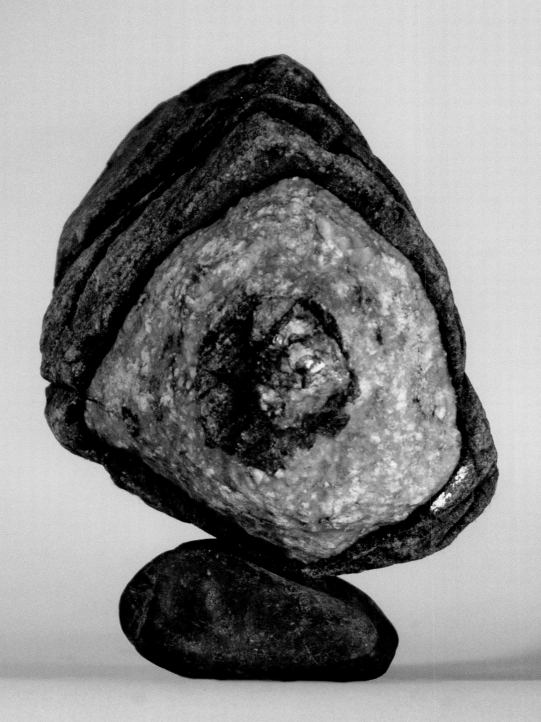

stones look back to me in their rise

verbal objects

the word stone is a stone word

When a word strikes us as ambiguous it spirals in the mind.

Sometimes the word *word* is such a word. What is it? How do we know it is there? Speaking is a chain of sounds with (re)marked differences: a first distinction decides if it is *language*. A *word* is a focus: a *sound* object, say, set off—poised (precariously) amidst other sounds—that I accept as meaning. Yet sometimes I hear my name but no one is there. My identity goes momentarily into disequilibrium. Not *my* word when I heard myself called, so who am *I?*

In a dream the status of a word, or maybe of *word itself,* may be left open, indeterminate: a sound may be a word and then not; it may be a stone grinding against a stone, making a sound that sounds like *stone;* or a hieroglyph *written in stone.* Perhaps I hear it saying: *I speak as stone.* Or simply see: STONE. Then the word fades away leaving only the stone itself, which however retains the *charge* of language, seeming to do more than simply exist as an object; it *says* itself. Which implies a certain life, and I call out: *Is someone there?*

Freud thought it very likely that the most ancient language operated like dream in not recognizing contradiction, as he argued in *The Interpretation of Dreams,* saying that in dreams there is no *no.* He referred to a pamphlet by a certain K. Abel, *The Antithetical Meaning of Primal Words* (1884). Dream logic, so to speak, with a law of non-contradiction: things exist side by side, paratactic. To choose *one* does not eliminate the other. Killing the enemy at some level may be a suicidal fantasy, or, as Norman O. Brown put it in *Love's Body* (1966), in Freudian logic, murder is a case of mistaken identity: one meant to kill oneself. Consequences of the antithetical meaning of primary *being*, or what Buddhists might think of as the law of non-separation of beings. Dualism is a sort of perspectival error.

It may not be interesting to argue along with Freud, for whom neurosis is identified with the inability to handle ambiguity, that the oldest words are intrinsically ambiguous and could mean opposites, discriminated by context or grammatical inflection; but it is probably a truer statement about all language. And that of course makes this statement unreliable—call it the Poet's Paradox. The very notion of validity, or at least the claim of discursive truth, may be an over-concretization of perspective. Blake makes more sense in saying:

Every thing possible to be believ'd is an image of truth.

—*The Marriage of Heaven and Hell* (1790)

Language in this perspective is fertile ground in which seeds of the axial grow as we speak.

So, *speaking spirals*, inevitably. And, for me, poetics is the study thereof, toward evolving a conscious practice that awakens awareness of what is happening.

What if each thing said made the world new? The purpose of speaking would be to join the other person in a mutual awakening. So language has to find itself out to make an opening within its immediate resources. Perhaps it has to fall through a crack in itself. What it utters while in that state of free fall I call a *preverb*. That's like a proverb that junked its dogma along the way. As Blake put it:

> If the fool would persist in his folly he would become wise.

That could almost serve as translation of the Tibetan notion of *crazy wisdom*.

And that reminds me of a recent visit by Tibetan friends Bhakha Tulku and his wife Sonam. When they looked at the picture of AXIAL STONES 25, they saw the form of a conch shell, which delighted them. They configured the upper stone according to a valued image, which of course it does somewhat resemble; for Tibetan Buddhists that image has a high status as one of the Eight Propitious Symbols. I have already mentioned Bhakha Tulku's gift for finding extraordinary stones and inscribing mantras on them, in effect transposing them to a "sacred set" as power objects. Or "verbal objects" at their most concentrated.

Two preverbs that came about at almost the same time in my mind suddenly become interchangeable:

> these stones speak for themselves

> these words speak for themselves

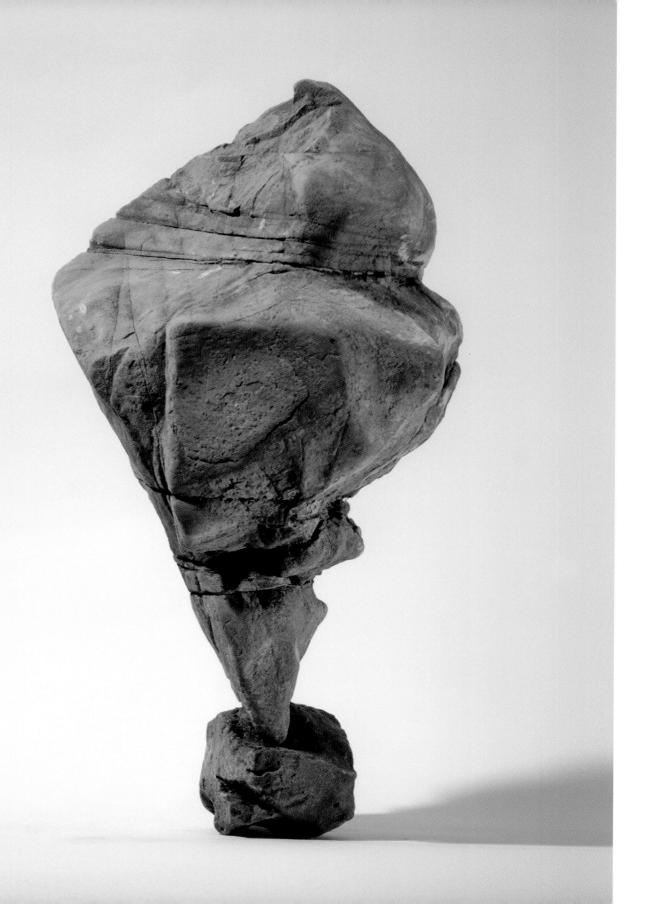

the bounding line speaks through what it is not

metalogue

In making this book I have tried to listen to the work for instruction, to the axial stones themselves. And now the book, here where we are, *is* the work. Taking the book as its own reality, I held the view that I should trust it to tell me what it wants, and, in fact, the book has taken shape pretty much without a plan—a sometimes unnerving process. If I had an intention for the whole, it was that the book should become an active space *between* mediums, a matrix of insight as to how a single principle can do its work equally in sculpture, drawing, and language. Although there is only a small presence here of axial drawing and poetics, my wish is that one be able to track a single axis running through them and the stones. A moment of insight between mediums is itself an axial event.

The text of the book comprises what I was able to say under the influence of the stones. And now the book is before us—I mean, it's there in *front;* I turn its pages; I see its images and hear its thoughts. Yet, so to speak, it's also now previous to this moment, as this is the *following discourse*—the metalogue, the zone of continuing reflection. It's a strange idea, but a work is always, axially, before itself. It sees itself emerging in its mirror, distant yet almost intolerably present, gnawing at possibility. At the same time, to the extent that it is its possible self, it's always already previous, and still waiting to happen, in order to become what it truly is. Art is a parlous life focus, always in the wings.

I don't mean any of this as a cleverness of thought, but as an inevitably failing attempt to characterize the *feel and time of work.* That time is a *now* that also shows up as the *speaking that comes after.* A "now" that is also an "after" that is really a "further": the *further life of the work*, and its continuance as completion through willing incompletion. At the same time (as it were), given the awareness that, on principle, the work is never ending, its sense of completion comes from knowing that, in each self-true event, it is as complete as it will ever be. *Completion* is intrinsic, contingent, and performative—utterly paradoxical.

this book is dedicated to

Chöegyal Namkhai Norbu, for showing us the real nature of collaboration

Susan Quasha, for a lifetime of collaboration, making possible everything worthwhile

buun [Chie Hasegawa], *garapancho,* for opening the axial stone path, and much more

The core: to settle into the center of the work is to contact zero point possibility. There is no limit to the emptiness (the openness) we can *let be* on the inside. Of course the release, the letting be, is ephemeral. It only takes place in this very moment, an unlocatable point in a space with no definable points. And so, we come to the axis: in momentaneity, working in a state of release touches a temporal invariable, *undertime,* and yet, working in real time and coming to the still point, it *furthers.*

It's happening in no time.

I offer this book in evidence for the view that art is fundamentally collaborative—a matrix, in yet another sense. I realize that art tends to show up on the art historical screen as heroic, competitive, and often fashionable, indeed, market-driven. Nevertheless I see its basic nature and function as managing the space *between* us, and the energetics of crossing that gap. This apparent "social" dynamic, paradoxically, is not in conflict with the impulse to travel the edge and a certain *bodily sublime*. The edge itself runs between us.

Perhaps the more a work is rooted in its own vision of reality, the more care it takes to acknowledge those who have made the recognition of vision possible. Of course, working on the scale of *life work* one finds no end to acknowledgement: one is a crossroads for confluence, which in the end may be even more important than influence, since it goes on, always a *present* phenomenon. That nexus also has its edge.

Looking back, I see the long trail leading to this spot, the connective strands, the people and the works. If I had the space I would talk in depth about how the very notion of the axial (and its predecessor *torsion*) arose many years ago, the linked events that made this and related work inevitable. Instead I will end this journey with little more than mentions and lists as the most basic *mapping* of how this came about. For me, merely saying the names of those who have contributed is a sort of rite of joyous nomenclature. And of expressed gratitude, itself an art, and one for which I have little aptitude. Perhaps the following speaking is also a repentance, a turning around.

a short personal account in the discovery of the axial

In the process of reading Blake's Illuminated poetic prophecies, while teaching at Stony Brook University in my early twenties, I discovered what I would then call *poetic torsion*, based in part on the morphological theory of D'Arcy Wentworth Thompson's 1917 two-volume *On Growth and Form*. While reading his "Further Note on Torsion," I awoke in the morning with a phrase in my mind, the residue of a dream: *The torque of Orc makes Blake an evolutionary revolutionary.* As I thought about this phrase (not without a certain *levity*), I realized a whole new approach to Blake's poetics, in which the revolutionary figure of Orc in *America a Prophecy* (1793) embodied poetic torsion—*the twisting force that rends all fixed patterns*. I was fortunate to be studying with the preeminent Blake scholar, the late David V. Erdman, who was, first, my teacher at NYU (in a post-graduate seminar in politics and literature, conducted also by Connor Cruise O'Brian) and, later, my colleague on the faculty of Stony Brook (SUNY). Erdman encouraged and published my work on Blake, "Orc as a Fiery Paradigm of Poetic Torsion" (*Visionary Forms Dramatic,* Princeton: 1970). In the course of this work I came to the basis of my understanding of what would become *axial poetics,* where "axial" means *the conscious, radical self-alignment that liberates identity/work into its unknown further possibility.*

A page from William Blake's Illuminated *America a Prophecy* (1793): poetic torsion as serpentine vortex visiting revolutionary justice on the King.

Early in the '60s, while an undergraduate at NYU, I met poets, composers, and artists (many around Café Le Metro on 2nd Avenue near 9th Street), too numerous to name, who would challenge my youthful poetics, which, however incompetently, derived from Wallace Stevens, among others. Especially important to me was Jackson Mac Low, whose free conception of "poetic text" and performance startled me, in fact often upset me, and caused me eventually to fundamentally alter basic views. Paul Blackburn upped the ante on what "ear" means in poetics. David Antin pushed my sense of voice and the cognitive/conceptual out to an edge, which I also resisted. These and other Lower East Side encounters (Diane di Prima, LeRoy Jones [later Amiri Baraka], Allen Ginsberg, Jerome Rothenberg, Harold Dicker, Ed Sanders, et al.) showed me at age 21 what it means for a radical practice to "axialize" language and the mind. I resisted, even tried to deny the impact it all was having, until one day it dawned on me, walking along Waverly Place near NYU where David Antin, Ed Sanders, Charles Stein, and I were studying, that hearing certain poems had changed everything, like it or not. This is how it goes. Art, life refocused, uproots the fixed view, and the work spins out to reorient to a shifting axis, finding a provisional alignment. A poetics takes shape as a sustaining and practicable view and a carrier of emergent values. If, however, it loses contact with the renewal function, it risks becoming dogma, and suffers from much the same limiting tendencies as religion.

John Cage and George Quasha discussing proofs of *Themes and Variations* (Station Hill Press: Barrytown, 1982).

The major encounters for me in my mid twenties were John Cage and Robert Duncan (they came to Stony Brook where I taught from 1965–71), both of whom, in different ways, fit my "Blakean" view of the work as vehicle, a way of engaging one's *further nature*, to take up Charles Olson's happy notion. Cage's *Silence,* which I began teaching in poetry classes, radically opened the *time* of composition/reading in "Lecture on Nothing," altering the very capacity of hearing ("our ears are now in excellent condition"). For Duncan too, but with a very different quality, the act of realizing the work is a realization the *work* enacts. This

event sense of art was, for Duncan, a truth living in the body of language, which the poet further embodied by surrendering within the material process of *telling.*

Certain acts of language—whether as single words, terms, phrases, sentences, passages, or whatever—alter one's reality, and become a clear matrix in which life newly emerges. (When I was 15 my friend Douglas Taylor read me the opening lines of Eliot's "Burnt Norton"—"Time present and time past /Are both perhaps present in time future..." and seemed to startle reality itself, enough for me to think: If *this* is poetry, I'm a poet.) The intensified life called *art* may be an attempt to return to that moment in which something said, told, thought changes everything—to *further enact it.* Such a view is a possible basis of art as *event*—consequential happening. Notions like Gertrude Stein's "continuous present" and "equilibrations," both taken up by Robert Duncan, emphasize process, activity, and immediacy as the site of meaning. Similarly powerful notions include, say, Cage's "unfocus," Olson's "field," Antin's "tuning," or Franz Kamin's "behavioral drift," all emphasizing a certain orientation and attentional disposition. The work as event realizes a certain *state,* as if suddenly showing through.

Meeting Susan Quasha (née Cohen) in Manhattan in 1970 (thanks to Charles Olson) and Charles Stein in 1971 (thanks to Susan) altered the basis of my work, which in complex ways has been pervasively collaborative, implicitly or explicitly, with them. A still unending conversation began, there on Christopher Street in a tiny apartment on the top floor of a former lighthouse, that is the undercurrent of it all. Not long after, we met Franz Kamin, whose high-voltage current (to stretch the metaphor) fed right in. Our dialogue with Robert Kelly was and is always a vital part of the field of polarities. Armand Schwerner insisted on complexity, with humor. And my year of working with Jerome Rothenberg, researching and creating *America a Prophecy: A New Reading of American Poetry from Pre-Columbian Times to the Present,* broadened and enriched the matrix. My main work of this time, *Somapoetics,* tracked the shifting axes and the torque of a virtual infrastructure in these crosscurrents and superimpositions.

Robert Duncan and Susan Quasha
in Barrytown, 1982.

In the summer of 1974, while Charles Stein, Rick Fields, and I were giving the first poetry workshops at the new Naropa Institute (now University), we continued studying with Chögyam Trungpa (whose poetry I published). We also studied briefly with Prof. Herbert Guenther, whose rigorous reframing of non-dogmatic perspectives on "awareness" made it possible to think together Blake's work, torsional poetics and art, and certain (commonly misunderstood) traditionary concepts, such as *shunyata* (translated as "openness" rather than "emptiness" in *The Tantric View of Life* [1972]). Equally important in this pivotal summer for me was another chance to experience John Cage, to study with Gregory Bateson, and to discover Tibetologist Steven Goodman (whose work in poetics I published), all vital to my story of the axial. Steven's doctorate under Guenther included working on the latter's masterpiece, *Matrix of Mystery: Scientific and Humanistic Aspects of rDzogs-chen Thought* (1984), which he later introduced us to along with Chöegyal Namkhai Norbu's *The Cycle of Day and Night* and Thinley Norbu Rinpoche's *Magic Dance,* also principal sources in the present concerns.

Our move from Manhattan to Barrytown in the Hudson Valley in '76 created the context in which to bring long-developing practice and work to fruition. Our many-year collaborations in the late '70s—including Charles Stein, Franz Kamin, Gary Hill, David Jones, David Arner, and others—focused for a while at the Arnolfini Art Center which we founded in Rhinebeck, New York. This matrix of intermedial performance served as testing ground for new approaches to individual work, and Barrytown became a crossroads of diverse art possibility. I could hardly overstate the importance of Gary Hill, Franz Kamin, Robert Kelly, and Charles Stein in this (re)sourceful process. When, at my suggestion, Dick Higgins and Alison Knowles bought a former church on Station Hill Road, Barrytown became yet another Fluxus outpost, bringing John Cage, Robert Filliou, and so many others to our doorstep. Composer John Beaulieu, who with Franz Kamin was part of the NYC performance collaborations, imparted his energetics research (Polarity, Craniosacral Therapy, Biosonic Repatterning, etc.), and has in recent times added new depths to my sense of the axial. Fredric Lehrman was invisibly part of the foundation and left traces of 'Pataphysical liminality. Community too can turn freely on invisible axes.

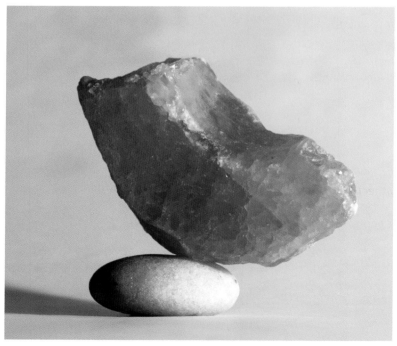

AXIAL STONES 40 where the upper "stone" is salt crystal, formed 25 million years ago near Krakow, Poland, and said to have healing properties; a gift from Nobuho Nagasawa's collection of salt, which she uses in her art.

further acknowledgments

FINDING STONES: As noted, I usually discover the stones that become axial, but some stones have been found by others: foremost among these, as mentioned, is Chie Hasegawa, who made the first work, **AXIAL STONES 0**, which first inspired this body of work, but notably the upper stone

Chie Hasegawa and Susan Quasha photographed by Barbara Leon in her house in Gardiner, New York.

of **AXIAL STONES 15** as well. She and Susan Quasha have collaborated with me in finding many other stones—along the Hudson River in Barrytown or Tivoli, at Bash Bish Falls, in Conway (Massachusetts) or Bennington (Vermont), to name the best places to date—to the point where it would be difficult to recall who found what.

Others who have given me stones that became axial include Barbara Leon (**AS 5 & 13**), Zhang Zhaoui (**AS 14**), Jenny Fox (**AS 22 & 37**), Nobuho Nagasawa (**AS 40**), and Sherry Williams (unrepresented here).

EXHIBITIONS: I am grateful to Manfred Baumgartner, whose immediate, clear, and enthusiastic response to the axial stones led him to spontaneously offer me the inaugural show of the relocated Baumgartner Gallery, 522 West 24th Street, NYC, in November of 2004. It's inspiring to discover a gallerist who acts on his love of art rather than market calculation; clearly he believes in "precarious balance." Moreover, his encouragement of the axial drawings was a critical force in my taking the work in a whole new direction. Thanks to Adrian Michaelson for sustaining energies and to Anne-Brigitte Sirois for the introduction to Manfred Baumgartner.

Allan Baer, Jan Harrison, and Linda Weintraub, longtime supporters of this and other work, gave invaluable assistance in the design, preparation, and execution of the Baumgartner Gallery show. Other friends who also made important contributions to that show include Jenny Fox, Sherry Williams, Jonathan Feldschuh, John Magner, Sara Seagull, Ashala Gabriel, and Ellen Ruth Topol.

The axial stones were, in fact, first exhibited briefly at the Westbeth Gallery in January of 2000 at the invitation of the late writer/artist Spencer Holst and artist Beate Wheeler. Spencer wrote a series of stories based on the axial stones called "Balanced Boulders," accompanied by the first published photos, in *Brilliant Silence: A Book of Paragraphs & Sentences and 13 Very, Very Short Stories* (Station Hill/Barrytown, Ltd.: 2000). This experience demonstrated the practicality of exhibiting the axial stones.

I wish also to thank my collaborators for the *Waterflow* exhibition (July-August, 2005) at the Cotuit Center for the Arts in Cape Cod: Ray Kass, Jamie Wolf, Virginia Sassman, and Irwin Kremen.

George Quasha balancing stones on the Hudson River shore in Barrytown, where many of the axial stones have originated from 1997 to present.

PUBLICATION: Richard Grossinger's enthusiastic response to the axial stones during a visit, generating his on-the-spot offer to publish this book, comprises, for me, one of those astonishing acts of spirit and generosity that gives publishing new meaning and possibility. Clearly this book would not exist on any level without his and Lindy Hough's support, which has resonated in my continuing work. The staff at North Atlantic Books has been an author's dream. Anastasia McGhee is the editor I wish to keep for this and future lives. Kathy Glass read the manuscript with healing attention. Debra Matsumoto's energetic personal response to the actual work inspires the promotional process. I am also grateful to Paula Morrison and Mark Ouimet for their helpful suggestions.

Sherry Williams has been a full collaborator on this book, which was born of our dialogue in image, design, and typography. Her patience and skillful persistence in our hunting down the "impossible" perspective and our long days and nights of work—months of setting up stones and photographing them again and again, shaping and reshaping pages—has made this book possible. Jenny Fox patiently read and reread the text as it evolved, offering invaluable suggestions at every point. (She is also recording the axial process on video for a developing work.) Chuck Stein too read the text with useful suggestions. Susan Quasha, as always, was the spirited mainstay and inspiring ground force that kept it all together, *sine qua non*. Together we have made a field of authorship.

Sherry Williams offering a stone found on the Hudson shore, Barrytown.

Carter Ratcliff's generous and careful attention to the work in the Foreword and, before that, in his review in *Art in America,* is an instance of criticism's higher function: to bring *further life* to a work.

Other versions of the text, especially parts of the Prologue, were published as earlier essays, including: "Axial Stones" in *Open Space Magazine*, #3 (Spring 2001), edited by Benjamin Boretz and Mary Lee Roberts, and, a later version, in *Ecopoetics* #2 (2002), edited by Jonathan Skinner; "Axial Drawing" in *Open Space Magazine*, #6 (Fall 2004), edited by Benjamin Boretz, Mary Lee Roberts, Tildy Bayer, Dorota Czerner; and "Axial Poetics" in *The Alterran Poetry Assemblage,* #5.0 (2000), [ca.geocities.com/alterra@rogers.com/] edited by David Dowker; in *Exquisite Corpse: A Journal of Letters and Life,* Cyber Issue 11 (Spring/summer 2002), [www.corpse.org/issue_11/manifestos] edited by Andrei Codrescu; and in *BeeHive ArcHive,* Vol. 5: #1 (July 2002), edited by Talan Memmott. [beehive.temporalimage.com/archive/51arc.html] Special thanks to the editors of these publications.

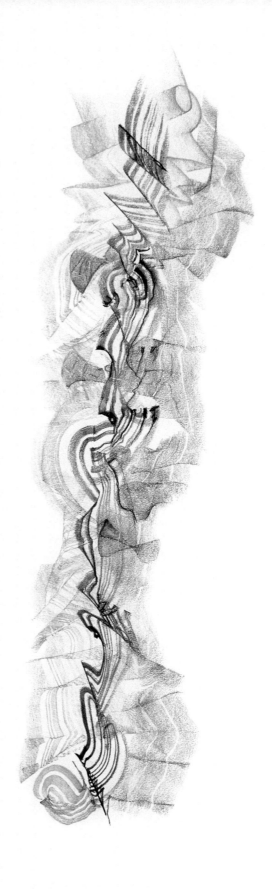

graphite: a note on further drawing

A few years ago painter and poet Linda Cassidy followed up a visit to our house by sending me a whole box of Tombo Professional Drawing Pencils #3B, because I had said that I draw only with ink, never with graphite or charcoal. She had described the joys of graphite, but I was only half-listening. The pencils sat around untouched for a number of months, because I hadn't been drawing seriously for a few years, concentrating instead on video works like **art is: Speaking Portraits (in the performative indicative),** which devoured time. Now faced with preparing an exhibition for Manfred Baumgartner, who unexpectedly was interested in the axial drawings as well as the axial stones, I felt that I should be engaging both. So I set about starting up the drawing; however, I was sadly unable to get back into drawing with ink. I began to think that axial drawing had abandoned me. Perhaps the gap had scared off the deities of ink. Somewhat anxiously I picked up the box of pencils, sharpened one, and began scribbling during dinner with Susan, mainly, I guess, to relax about the issue of drawing. At the end of the meal I looked at what I had done, which no longer felt quite like scribbling, and was shocked to discover that it looked like nothing I'd ever done (or, really, *seen*). But it was alive. Getting excited, I continued working it for a long while and felt the familiar sensation of a whole new world of work opening of its own accord. Then I did two more drawings lasting till dawn!

Now I knew the door was fully open. And Linda had served as Faerie Queen, her wand a beautiful Tombo #3B, which revealed to me the magic of graphite. Without notice, I had a new medium of choice.

Eventually Linda became a collaborator in what I would call *axial life drawing*. The notion of axial life drawing had come to mind when artist Mark Thomas Kanter offered to let me sit in on his life drawing sessions with live model. I said that I didn't draw from models or in fact anything external, but that I might be interested in drawing with my back to the model, just working from the energy. Or perhaps drawing directly on her body by putting paper against her and following its curves 3-dimensionally. He was willing, but I never got around to it. I did later try it when Linda was visiting and the poet Dorota Czerner agreed to participate, letting us cover her whole body with a huge sheet of paper. Linda and I drew simultaneously—two-bodied drawing, collaborating with the model. The result was sculptural. The drawing was alive. But this is another story.

Two axial drawings, graphite, two-handed, 18" x 24.5"
(45.7 x 62.2 cm), (left and right) August 28, 2005.

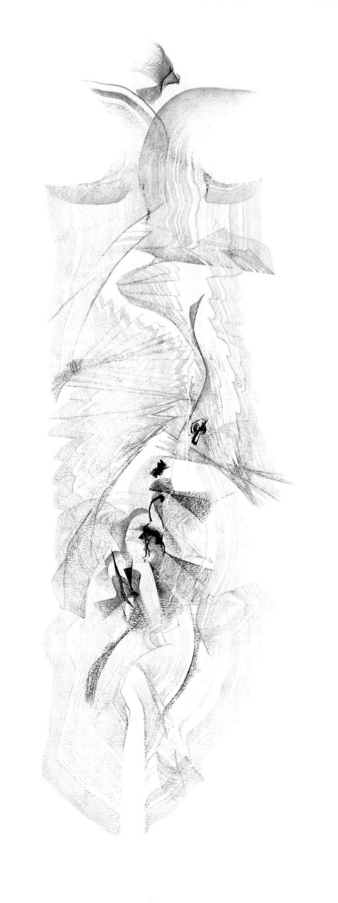

further collaborations

Franz Kamin's fervent support of this work has included urging me for several years to do a book of the axial stones.

Jonathan Feldschuh has been a friend of my work for many years and a poignant source of critical perspective throughout the work of axial stones. Likewise Barbara Leon and Nobuho (Nobi) Nagasawa, profound collaborators beyond description.

Ted Denyer, our late and forever magnificent friend and artist, whose supportive interest in my (and Susan's) work was a rare gift, is now a "property of the mind" and always here with the work. This book is also for him.

Franz Kamin in Minneapolis, Minnesota.

Juan Puntes, whose invitation to be on the White Box Board of Advisors and particular help with specific works—especially **art is: Speaking Portraits (in the performative indicative) [www.artis-online.net]** exhibited at White Box in Chelsea (New York City)—has made for a rich field of associations; thanks also for valuable suggestions regarding my exhibitions, axial drawings, and the present book.

My other longtime supporters of this and related work have served its energetic field in many ways: David Arner, John Beaulieu, Harvey Bialy, Linda Cassidy, Laura Chkhetiani, Michael Coffey, Dorota Czerner, Jeanne Englert, Peggy Gummere, Richard (Buzz) Gummere, Jr., Nor Hall, Chrissie Iles, Ione, Alison Knowles, Stephen Korns, Anastasia McGhee, Pauline Oliveros, Raquel Rabinovich, José Reisig, Andra Samelson, Samten, Carolee Schneemann, Merab Uridia, Lissa Wolsak, Roger Woolger.

Ted Denyer in photo portrait by Jonathan Feldschuh, Barrytown, 2004.

I am grateful for supportive responses to the work from Ammiel Alcalay, William Anastasi, Kathleen Anderson, Anthea Appel, Janus Avivson, Susan Bee, Logan Beitman, Charles Bernstein, Bhakha Tulku, Xu Bing, Dove Bradshaw, Mary Caponegro, Steven Chaikin, Phillip Corner, Jaime Davidovich, Solange Fabião, Carla Feldschuh, Roxanne Fischer, Nadège Foofat, June Fortess, Chris Fynsk, Ashala Gabriel, Grady Gerbracht, Peter Goldfarb, Maria Gorens, Mahmoud Hamadani, David Hammons, Jessica Higgins, James Hillman, Jim Holl, Steven Holl, Toine Horvers, Heather Hutchison, John Isaacs, Tim Jacobs, Mark Thomas Kanter, Matthew Kapstein, Eva Karczag, Jane Laudi, Pat Lipsky, Chris Mann, Mona Mark, Anthony McCall, Thomas McEvilley, Margot McLean, Adrian Michaelson, Larry Miller, Robert Morgan, Tom Nozkowski, Nilufer Ovalioglu, Dina Pearlman, Isabela Prado, Joshua Selman, Anne-Brigitte Sirois, Rebecca Smith, Michael Snow, Jeffrey Stuker, Drake Stutesman, Suzi Sureck, Lama Tharchin, Tenzin Wangyal, John Weber, Lilly Wei, Gary Weisberg, Mark Weiss, Barb Whan, Susan Wides.

Choegyal Namkhai Norbu with Samten in the Quashas' house on Station Hill Road in Barrytown, 1992.

Published by North Atlantic Books
P.O. Box 12327
Berkeley, California 94712

Cover design by Sherry Williams
Interior book design collaboration by Sherry Williams and George Quasha
Design consultant Susan Quasha

Photos of axial stones by Sherry Williams

Additional photos (© 2006 in the name of the photographer) listed by page number: 24, all photos courtesy of Gary Hill Studio; 51, Susan Quasha; 112, (top and bottom), Jenny Fox; 114, (upper left and bottom right) Barbara Leon; 118, Barbara Leon; 120, Ray Borem; 122, (bottom) Jim Edwards; 123, (top) IKONOS satellite image courtesy of GeoEye, (middle and bot-tom), Jim Edwards; 152, (bottom) Susan Quasha; 153, George Quasha; 154, (top) Barbara Leon; 155, (top) Sherry Williams, (bottom) George Quasha; 158, (top) Richard Gitler, (middle) Jonathan Feldschuh, (bottom) Susan Quasha.

Citations on page 120 and 122 from "The Spiral Jetty," *Robert Smithson: The Collected Writings,* ed. Jack Flam, (University of California Press: Berkeley, 1996), © 1996 by the Estate of Robert Smithson.

Special thanks to Tilman Reitzle for technical and personal support.

Printed in Singapore
Distributed to the book trade by Publishers Group West

Axial Stones: An Art of Precarious Balance is sponsored by the Society for the Study of Native Arts and Sciences, a non-profit educational corporation whose goals are to develop an educational and crosscultural perspective linking various scientific, social, and artistic fields; to nurture a holistic view of arts, sciences, humanities, and healing; and to publish and distribute literature on the relationship of mind, body, and nature.

North Atlantic Books' publications are available through most bookstores.
For further information, call 800-337-2665 or visit our website at www.northatlanticbooks.com.
Substantial discounts on bulk quantities are available to corporations, professional associations, and other organizations. For details and discount information, contact our special sales department.

Library of Congress Cataloging-in-Publication Data

Quasha, George.
 Axial stones : an art of precarious balance / by George Quasha.
 p. cm.
 Summary: "Improbably balanced stone sculptures, strangely beautiful, often
large, natural rocks, seemingly on the verge of falling, which, together with
interwoven stories and discussions, create an experience of the 'bodily
sublime'—the exhilarating but sometimes hair-raising state of nature (and
art) pushed to a limit"—Provided by publisher.
 ISBN 1-55643-575-4 (trade paper)
 1. Quasha, George—Themes, motives. 2. Rock balancing—United States. 3.
Spirituality in art. 4. Nature (Aesthetics) I. Title: Art of precarious
balance. II. Title.
 N6537.Q37A4 2006
 709.2—dc22

 2006004412

1 2 3 4 5 6 7 8 9 TWP 12 11 10 09 08 07 06